IMAGES
of America

CLARKSVILLE
INDIANA

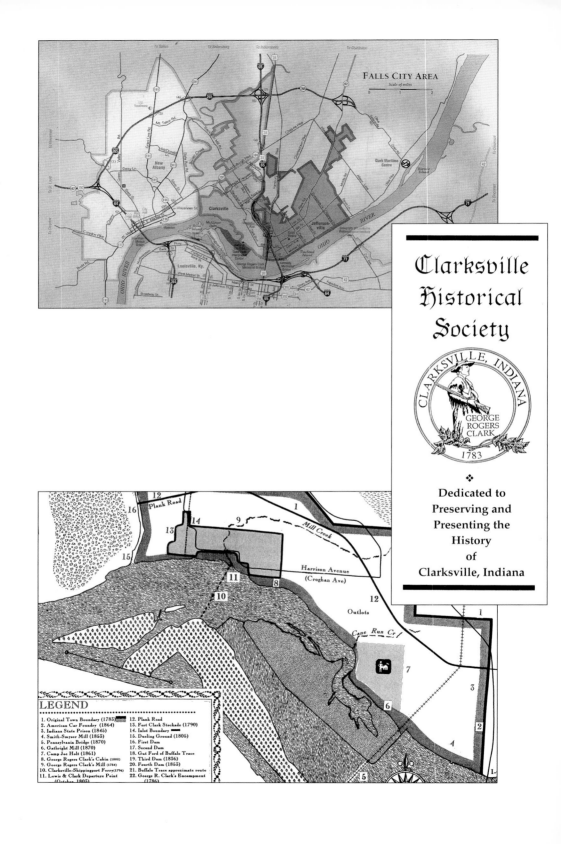

FALLS CITY AREA

Scale of miles

Clarksville
Historical
Society

CLARKSVILLE, INDIANA

GEORGE
ROGERS
CLARK

1783

❖

Dedicated to
Preserving and
Presenting the
History
of
Clarksville, Indiana

Plank Road

Mill Creek

Harrison Avenue
(Croghan Ave)

Outlots

Cane Run Cr

LEGEND

1. Original Town Boundary (1785)
2. American Car Foundry (1864)
3. Indiana State Prison (1845)
4. Smith-Smyser Mill (1855)
5. Pennsylvania Bridge (1870)
6. Gathright Mill (1870)
7. Camp Joe Holt (1861)
8. George Rogers Clark's Cabin (1802)
9. George Rogers Clark's Mill (1784)
10. Clarksville-Shippingport Ferry (1786)
11. Lewis & Clark Departure Point
(October 1803)
12. Plank Road
13. Fort Clark Stockade (1790)
14. Inlot Boundary
15. Dueling Ground (1805)
16. First Dam
17. Second Dam
18. Gut Ford of Buffalo Trace
19. Third Dam (1856)
20. Fourth Dam (1855)
21. Buffalo Trace approximate route
22. George R. Clark's Encampment
(1786)

IMAGES
of America

CLARKSVILLE
INDIANA

Jane Sarles

ARCADIA

Published by Arcadia Publishing
Charleston SC, Chicago IL, Portsmouth NH, San Francisco CA

Printed in Great Britain

Library of Congress Catalog Card Number: 2001093320

For all general information contact Arcadia Publishing at:
Telephone 843-853-2070
Fax 843-853-0044
E-mail sales@arcadiapublishing.com
For customer service and orders:
Toll-Free 1-888-313-2665

Visit us on the internet at http://www.arcadiapublishing.com

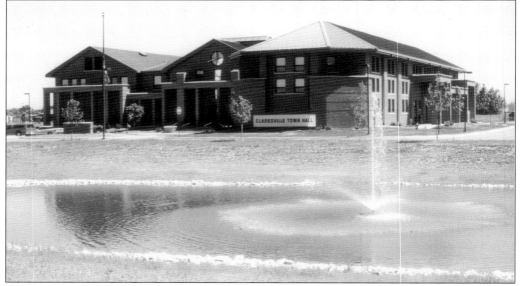

MUNICIPAL CENTER. Although the town is more than 200 years old, a building to house the government has never been built. For many years, town records were in the keeping of whomever were the town councilmen at the time. In the early 1970s, a remodeled private home served as town hall. When the Colgate school closed, the town purchased it and moved the government into that building in August of 1978. The only room suitable for town meetings was on the second floor and there was no elevator, so the building did not comply with the Americans With Disabilities Act, and new quarters had to be found.

Tax district changes caused money to be available from the growing commercial development and land became available in a section of town that was more centralized than the old school had been. As a result, a new town hall and municipal was erected, the first ever built specifically for this purpose. Town government moved into the building in the fall of 1995.

CONTENTS

ACKNOWLEDGMENTS

We would like to thank the many people who contributed photographs for this effort. First of all, our gratitude goes to the Clarksville History Society, whose photograph collection formed the greater part of those used. Society members who contributed information and/or loaned us their treasured family photos are: Joan Oehmann, Gary J. Nokes, Eva Jo Franz, Bob Popp, Don Tetley, Amy Jo Munich, Danny Spainhour, Richard Dickman, Edward Finch, Don and Martha McDonough, and Bill Stodghill. Particular thanks should go to Barbara Rice and Lynda Riggle Meyer for their invaluable assistance in so many ways.

We wish to thank Randall Baird for the loan of photographs and for providing information.

A great deal of gratitude is due town council president, John Minta, and the entire Clarksville Town Council, for their unwavering support of the Clarksville History Society in its effort to preserve the town's past. Councilman Robert Popp is owed a special thanks for lighting the spark that flourished and grew into the society of today.

Our thanks to the Jeffersonville Public Library reference department for their generous help in locating photographs.

The assistance of *The Jeffersonville Evening News* has been invaluable. Without their having recorded the events of the past 130 years, our knowledge of Clarksville's past would be woefully inadequate. We also owe senior editor John Gilkey our thanks for his generous assistance in the preparation of this book.

We owe a debt of gratitude to the Falls of the Ohio State Park, particularly Alan Goldstein, Stephen Knowles and Dani Cummins, for allowing us access to their collections of photographs and materials.

Special thanks goes to the Indiana State Library for their permission to use their photo of the Civil War period.

My personal thanks to Christopher Fitzpatrick who shared his limited time.

Some photos used were from the *Louisville Courier-Journal* photograph library.

Our sincere apologies to anyone whose name is inadvertently omitted here.

Sources of information on Clarksville History were:

> The Minutes of the Clarksville Town Council, 1784–1889
> The information files of the Jeffersonville and New Albany-Floyd County Libraries
> Newspaper Articles by Carl Kramer on local gambling
> *Baird's History of Clark County*
> *The Encyclopedia of Louisville*, John Kleber, ed. Univ. Press of Ky, 2001
> *The Pulse*, Volume III, #3: booklet published by The Colgate Company, March 1931
> Illustrated Souvenir of Indiana Reformatory, 1906 and 1911
> *The Evening News* (Jeffersonville, Indiana)
> The archives of the Clarksville History Society

INTRODUCTION

A Brief History of Clarksville

Clarksville's history goes back to the American Revolution. At the end of that war, the state of Virginia owned much of the land that was later to become the Northwest Territory. In January of 1778, George Rogers Clark asked for and obtained permission from Virginia Governor Patrick Henry to attack and capture the forts of Kaskaskia, Cahokia, and Vincennes in the British-held territory north and west of the Falls of the Ohio.

Clark established a base on a small island above the Falls near what would soon become the town of Louisville. He trained his army, the 175 men of the Illinois Regiment, on the island and in June of 1778 they journeyed down the river toward the British forts. This very difficult but successful campaign provided the basis for a later claim of the new United States to the entire Northwest Territory. Had he not succeeded, the states of Indiana, Illinois, Ohio, Wisconsin, Michigan, and part of Minnesota might now be Canadian land.

To recognize the magnitude of Clark's concept and the bravery it required to accomplish it, the state of Virginia, on January 2, 1781, adopted a resolution awarding a grant of "a quantity of land not to exceed 150,000 acres . . . in such place on the northwest side of the Ohio as the majority of the officers shall choose." By 1783 the location of the grant had been determined and the Virginia legislature ordered that the land be surveyed and that the commissioners it appointed set aside 1000 acres at the most convenient place for a town, to be called Clarksville.

The Virginia law mandated that particular persons be named trustees of the new town. They were George Rogers Clark, William Fleming, John Edwards, John Campbell, Walker Daniel, John Montgomery, Abraham Chaplin, John Bailey, Robert Todd, and William Clark, a cousin of George Rogers Clark. They were to lay off lots of half-an-acre each, with convenient streets and public lots.

The trustees were vested with the power to elect replacements to the board in case of death or removal, so it became a self-perpetuating board. It was not until after 1889 that the structure of the board was changed to a three-member board with one each appointed by the commissioners of Clark and Floyd Counties and one elected by the residents of the town. Sometime before 1937 the make-up of the board again was changed, to five members, all to be elected by town citizens. In 1990 the board expanded its membership to seven and the town continues to be governed by the successors of that original council.

Settlement began in 1783, and shortly after Captain Robert George and a company of soldiers built a stockade, Fort Clark, for protection from the Native Americans who still roamed the woods west and north of Silver Creek. Settlers lived in the stockade for two years before building their cabins. A visitor to Clarksville in 1788 noted that there were only seven or eight houses in the town. By 1790 the population was about 60 people.

Moses McCann was one of the original settlers of the town. He bought his first lot on March 1, 1786, and added five other lots in 1794. McCann had one of the first ferries across Silver Creek, getting his license in 1801. He ran afoul of authorities in January of 1802, when

he "feloniously, maliciously and of his malice aforethought did make an assault and that the aforesaid Moses McCann with a certain tomahawk made of iron, of the value of two dollars, which the said Moses McCann in his right hand then and there held, in and upon the head of the said Indian strike, giving to the said Indian one mortal wound of the breadth of two inches and of the depth of one inch, of which said mortal wound he, the said Indian, on the day aforesaid, died." The Native American was a member of the Shawnee tribe. The charge must have taken longer to prepare than McCann's punishment lasted, as he was put under bond to keep the peace for one year and released.

General Clark built a gristmill on Mill Creek in 1784. In 1803 he built the only home he ever owned on a large bluff overlooking both the town and the Falls of the Ohio. He lived in Clarksville until 1809, when ill health caused him to stay with his sister at Locust Grove in nearby Louisville until his death.

George's brother, William, was also a Clarksville resident and was appointed to the town board as trustee. He took an active part in town affairs, becoming surveyor of the town in December of 1802. William spent much of early 1803 surveying for new roads. At the request of the council he designed a bridge over Mill Creek which was built by April of 1803.

On June 19 of the same year, Meriwether Lewis wrote to William Clark and suggested that he share command of an expedition conceived by President Thomas Jefferson to explore the unknown western lands to the Pacific Ocean. William accepted immediately and, in October of 1803, Lewis—after taking his keelboat down the Ohio from Pittsburgh—joined William Clark at the Falls. The two men spent almost two weeks there while recruiting the nucleus of the Corps of Discovery from the local area. The party, consisting of Meriwether Lewis, William Clark, Clark' slave York, and the "nine young men from Kentucky" left Clarksville on October 26, 1803. At the end of their historic journey Lewis and Clark returned to Clarksville on November 5, 1806. Jonathan Clark, older brother to George and William, wrote in his diary, "Captains Lewis and Clark arrived at the Falls on their return from the Pacific Ocean after an absence of a little more than three years."

From Clarksville the two men went their separate ways, Lewis to an untimely death on the Natchez Trace in 1809, and William Clark eventually to become the Governor of the Missouri

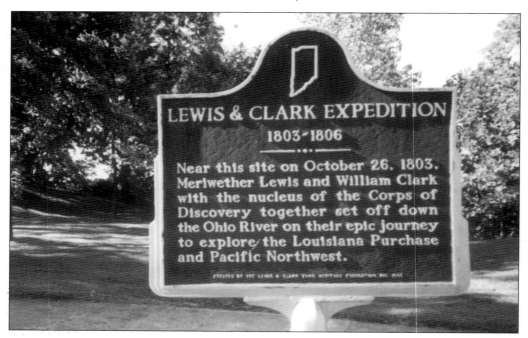

Territory.

The Buffalo Trace, an ancient buffalo trail which led from the salt licks of Kentucky to the plains of present-day Illinois and beyond, was an important pioneer road. The trace crossed the Ohio River at the Falls—its shallowest point for many miles—and emerged on the west side of Clarksville, at about Vincennes Street, now Emery Crossing Road. Continuing north, it crossed Silver Creek at the "Gut" Ford, turning westward in neighboring Floyd County. It was the only road through the wilderness to Vincennes, the only other settled part of Southern Indiana in the late-18th century. Many travelers, American and foreign, passed through Clarksville on their journeys to the west.

General Clark died on February 13, 1818. The town founded in his name had failed to flourish. Frequent floods were a problem and residents moved to higher ground. Many of the original landowners were adventurers who moved on to other adventures. Trustees were not required to be residents of the town, which led to lax oversight of maintenance and few civic improvements. Ferries began to cross the Ohio west of Louisville, bypassing Clarksville's section of the trace. Throughout this difficult time, however, the town was never abandoned. Citizens lived there throughout the 19th century.

During the years from 1805 to 1841, Clarksville served as the "dueling ground" for Kentuckians avoiding the laws that forbade dueling in their state. They would ferry across the Ohio to the mouth of Silver Creek and hold their duels there. One of the most famous duels was fought between Henry Clay and Humphrey Marshall in 1809. Both men survived.

Originally built in 1821 in Jeffersonville, the state prison moved to Clarksville in 1845. The prison received all prisoners, both male and female, convicted in the courts of Indiana until 1861, when a second prison was built at Michigan City in the northern part of the state. In 1873 a women's prison was built and in October of that year it received all women from the Clarksville prison. A disastrous fire in 1918 brought about the sale of the property and the complex of buildings became the Colgate Company in 1924, and remains so today. Some of the original buildings remain at the site. An important feature of the Colgate plant has, since its opening, been the clock atop one of the buildings. It is the second largest clock in the world and is easily visible to Louisvillians across the mile-wide Ohio.

During the Civil War, a mustering camp named for the Union Secretary of War Joe Holt was established on the Clarksville riverfront. It later became a military hospital throughout much of the war. When the hospital closed, the site again became Camp Joe Holt—a staging area for the troops headed south. After the war its buildings were moved to serve other uses. One became the chapel of St. Paul's Episcopal Church in Jeffersonville.

The last ferry from Clarksville to Kentucky ceased operation in 1850. As early as 1837, a project was started to build a bridge to connect Indiana and Kentucky. This was intended as a carriage bridge, since railroads were barely thought of at the time. Work was commenced on a foundation, but lack of funds caused a cessation of the work. The first successful attempt to bridge the river was during the Civil War, when a pontoon bridge transported troops and supplies between Indiana and Kentucky. After the war, the bridge project was revived and by 1867 construction had begun. The bridge was dedicated on February 18, 1870. It was considered one of the engineering wonders of the country.

The Ohio Falls Car and Locomotive Company was built in 1864 to produce railroad cars and equipment. The facility burned in 1872. By 1876, the plant had been reorganized and rebuilt as the Ohio Falls Car Company. In 1899 it became the American Car Foundry and manufactured railroad cars at the rate of one a day. During World War I the company was the government's largest contractor and the Clarksville plant made a variety of metal military equipment. The Car Foundry closed in 1933. A number of the 1872 buildings remain and are being restored.

Clarksville slumbered through much of the late-19th century. It so lost its identity that another town was formed within it and named "Ohio Falls City." Clarksville still had an official existence however, and the Indiana Supreme Court ruled that a town couldn't be established within the confines of an existing town.

During the "Roaring Twenties" Clarksville became a center of gambling and nightlife for the entire metropolitan area. The Greyhound dog-racing track opened in 1929. Roadhouses were popular and there were many in the area of present Highway 131 and Blackiston Mill Road. They included the Lido Venice, Phipps Roadhouse, the Log Cabin, and the Lighthouse.

The 1937 flood, which brought ruin to the entire Ohio River Valley, took a terrible toll on Clarksville as well. The Corps of Engineers began a floodwall project to ensure that such devastating damage would not happen again. The path of the floodwall was carved through some of Clarksville's most historic land. The old Cobblestone Pike, one of the town's earliest roads, was among the landmarks obliterated by the wall. Flood protection, though welcome, has come at a price for the town's history.

With the housing boom that followed World War II, Clarksville's population soared, and in 1940 reached 2,400. The development of new neighborhoods and the annexation of existing ones has brought the town growth in area as well as population. By 2000 the town extended as far north as Sellersburg, 7-miles away, and had more than 22,000 inhabitants. A thriving commercial district containing two malls and dozens of other businesses bring shoppers and visitors from several counties in Indiana as well as Kentucky. The new section of Clarksville is a vibrant and growing place, but the original town, on the National Register of Historic Places, is undeveloped and unrestored. Efforts are underway to preserve it, mark it, and make today's Clarksvillians and all those interested in our historic past aware of its unique place in the region's history.

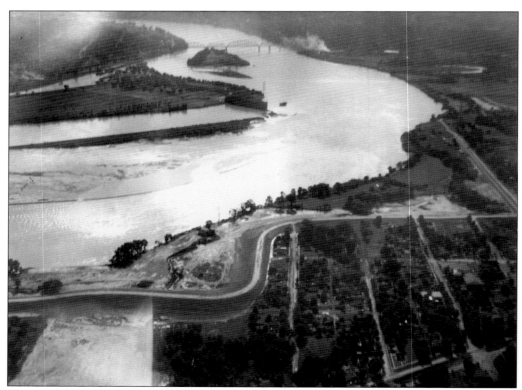

CLARKSVILLE RIVERFRONT. The Corps of Engineer's levee under construction is shown in this photo. The original town site and George Rogers Clark's cabin site is at upper right, where the road ends at the river. The McAlpine locks are at upper left. The Howard Park section of Clarksville is at lower right.

One

PEOPLE

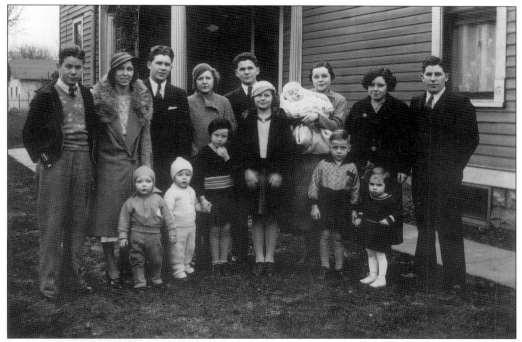

TWO GENERATIONS OF THE WILLIAM AND JULIA O'BRIEN FAMILY. They are pictured at the Stansifer Avenue home of Nora O'Brien Graninger on Christmas Day in 1933. Nora's father, William O'Brien, was born in County Cork, Ireland and immigrated to the United States in 1872. William married Julia O'Sullivan from Canada and settled in Grayson County, Kentucky, where they had ten children. William renounced his allegiance to Queen Victoria on November 2, 1896, at the age of 39 and became an American citizen in Louisville, Kentucky. The O'Brien family moved to Clarksville, Indiana, where Nora O'Brien met and married John David Graninger. Two generations of O'Briens and three generations of Graningers lived in the home on Stansifer Avenue. The house burned in 1978 causing the death of John Joseph Graninger Sr.

THE GRANINGER HOME. Probably one of the first homes in Howard Park, the house was built by Joe and Teresa Graninger. It originally had a sleeping porch, which has since been removed. Joe Graninger was said to have personally inspected every piece of lumber used in the home. The couple had started a grocery store at 340 Stansifer Avenue in 1882 and lived in the back of the store until their home was built across the street from the grocery in 1882. The couple had four children: Maggie, Joseph, Katherine, and John David.

Daughter Maggie never married and operated the store with her sister Katie after their parent's death. She had a small post office, one of Clarksville's first, in the store. Maggie became active in politics after the death of her brother, Joe, who was a precinct committeeman. She eventually became quite powerful in the local Democratic party and it was said you had to get her approval before running for Democratic office in Clark County. Katie died in 1960 and Maggie in 1981.

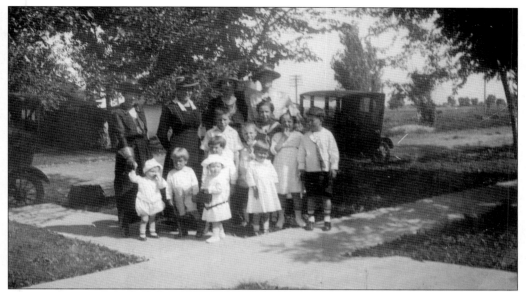

VISITING GRANDMA GRANINGER. Part of the Graninger family is shown in front of the home of John David and Nora Graninger's home on Stansifer Avenue in 1920. John David was the son of Joe and Teresa Graninger who were the first of the family to move to Clarksville. John David had a road construction business and built roads in the Fort Knox (Kentucky) area during World War I. He contacted flu during the great epidemic of that time and died in 1918 at age 33.

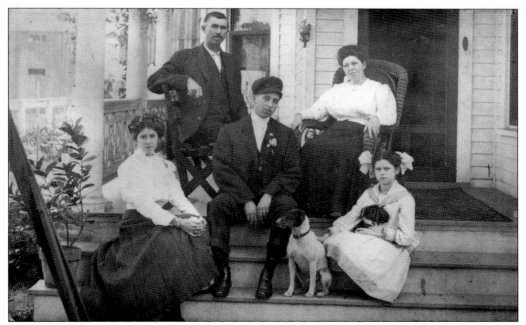

THE DETRICK FAMILY. Mr. and Mrs. Edward Detrick are shown with their children about 1910. Pictured, from left to right, are May, Louis, and Cecil. The family lived in a two-story house on Harrison Avenue. Son Louie later owned a gasoline station at the corner of Randolph and Harrison Avenues.

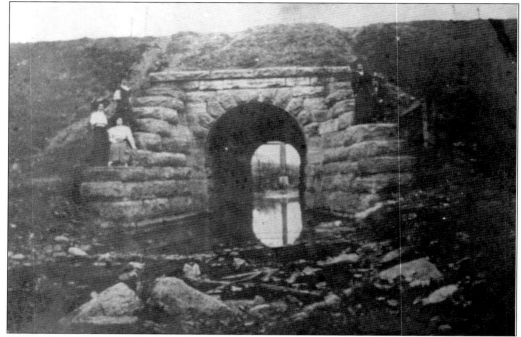

THREE LADIES ON AN OUTING. This photo was taken on September 4, 1909. It shows Iva Stewart, Della Stewart, and May Ike at Mill Creek, where it flows under the railroad overpass, just north of Harrison Avenue. The gentlemen to the right are unidentified.

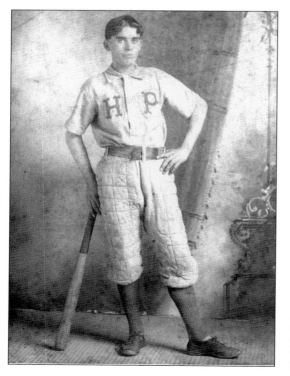

ED MITCHELL. Ed is shown in his Howard Park baseball uniform. Born in 1883, he played professional ball at a time when the players were paid by passing the hat among the spectators. Ed's wife Bertha worked at Clarksville's first post office. They lived on Elm Street and had two children, Carlos and Juanita.

CARLOS MITCHELL. Carlos is shown as an Ohio Falls School sixth grader. The son of Ed Mitchell and his wife Bertha Bunnell Mitchell, Carlos married Evelyn Hume and had children Bill, Bud, Betty, Pat, Loren, Robert, and Juanita. As a young man, Carlos was the Clarksville Marble champion and represented the town in a Louisville marble tournament. Not many knew that his sister Juanita had actually beaten Carlos in the local contest, but since girls were not allowed to participate in the Louisville tournament, Carlos went instead.

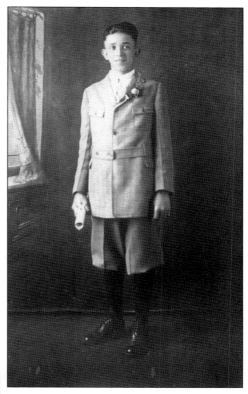

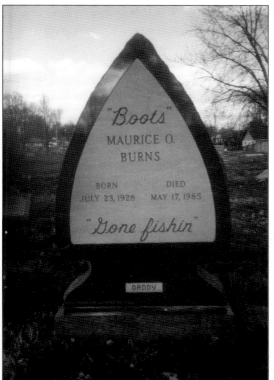

BOOTS BURNS. The tombstone is that of "Boots" Burns, and is shaped like an arrowhead because of his extensive collection of the artifacts. As one of Clarksville's rivermen, Boots grew up on the Falls of the Ohio. He got his nickname from the high-top, hobnailed boots he wore. Local legend has it that some of his arrowheads were buried with him when he died, in the manner of the Native Americans.

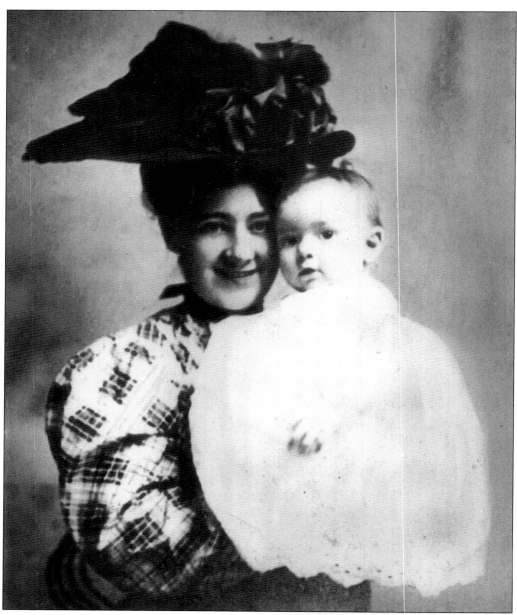

AMY SCHULER BAIRD. The daughter of Alfred Otto Schuler, owner of a Jeffersonville dry goods store, Amy moved to Clarksville and married James Baird. She is pictured with her son, James. The couple had eight children. Their home on Harrison Avenue was one of the oldest buildings in Clarksville and was originally a two-story log home. Well over a hundred years old, it is still occupied by a member of the Baird family.

Mrs. Baird was an active participant in the family's dairy and ice cream business. As one of the first woman drivers in the county, she drove the milk delivery truck. She served on the Clark County Welfare Board and was a Sunday School teacher at Howard Park Christian Church for 40 years. She organized and was the first president of the George Rogers Clark School Parent-Teacher Association. She died in 1990 at age 105.

THE BAIRD FAMILY. Amy (Mrs. James) Baird is shown with her father, A.O. Schuler, and five of her children at her home at 321 Harrison Avenue. Pictured, from left to right, are as follows: (front row) Amy, Libby, and Louise; (back row) James A., Schuler, and Levy. The photo was taken in 1918.

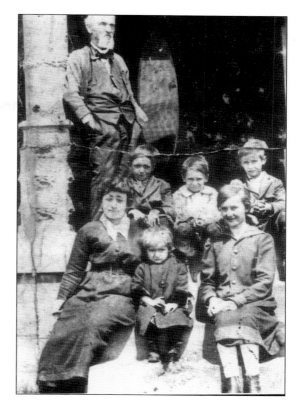

LAURA MITCHELL. Known as the "Angel of Clarksville," Laura is shown in 1906. She was one of seven children who grew up in a very devout home. Her mother was occasionally called upon to preach the sermon in the absence of the minister. Laura was one of the founders of the Howard Park Christian Church.

THE HALE FAMILY. Shown is Clarence Hale in front of the family's home near the Ohio River. The home was built about 1900. There were four brothers and one sister in the family. The brothers—Clarence, Urban, Eddie, and Peter—never married and lived together in the family home all their lives. They were known for their ability as commercial fishermen and were usually to be found on the river, but also raised crops, vegetables and livestock on a farm that encompassed much of the original Clarksville town site. The brothers were collectors of the huge variety of Native-American artifacts that were to be found along the river, and their collection was considered one of the best in the area. Pete functioned as head of the family and was the only one who drove a car. They were a musical family and Pete built and played his own bass fiddle. They enjoyed entertaining groups of friends and other fisherman, often serving fish they had caught. Eddie passed away first in the 1940s. Pete lived into his 90s, dying in 1996.

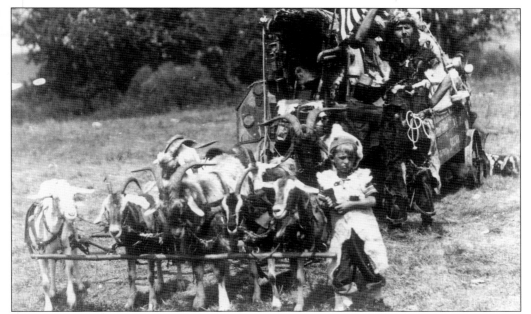

A Regular Visitor. Periodically, Clarksville would receive a visit from "the goat man." He never failed to attract attention with his caravan of goats and his small wagon piled high with pots, pans, odds, and ends. Many town residents had their picture taken with him. He would camp at the edge of town for a day or two before moving on to other adventures.

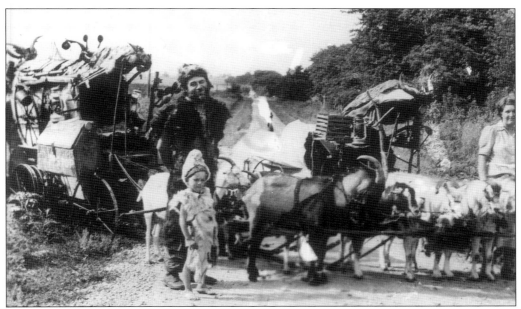

The Goat Man. Ches McCartney was born in Iowa in 1901. He married several times—once reputedly to a Spanish knife thrower. His son is shown in this photo with him. Ches sold items such as postcards, which he sold for 25¢ each, or three for $1.00. He said he was inspired to spend his life wandering by the book, *Robinson Crusoe*. He ended his days in a nursing home in Georgia, dying in November 1998, at 97 years of age.

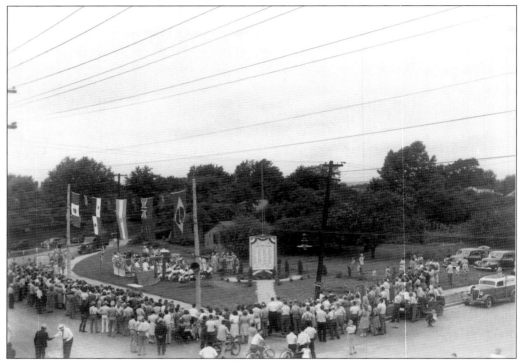

THE ROLL OF HONOR. During World War II, the town erected a Roll of Honor listing Clarksville servicemen. It was located at Stansifer Avenue at Elm Street on land donated by Mrs. Agnes Hudson, owner of Hudson's Grocery. She later received a Good Citizen award for her contribution.

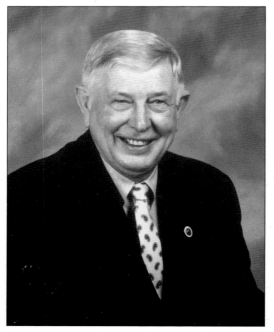

COUNCIL PRESIDENT. John Minta is a lifelong Clarksville resident. From 1974 through 1984 he served on the Parks Board. He was elected to the Town Council in 1984 and again in 1992. Since 1999, he has served as President of the Town Council, equivalent to a city's mayor. Mr. Minta has ended more than 200 years of neglect and decline of the original Clarksville site, initiating a project to transform the historic location into a restored interpretive and commemorative area.

CLARKSVILLE WOMEN'S CLUB. Members are shown in the early 1940s. They are, from left to right, as follows: Pat Devine, Penny Whittington, Catherine Baird, Thelma Garvey, ? Bottorff, ? Hudson, Julia Devine, and Libby Chapman Baird. Catherine Baird became the first woman to sit on the Clarksville Town Board when she was appointed to fill husband Leviston Baird's position after his death in 1944.

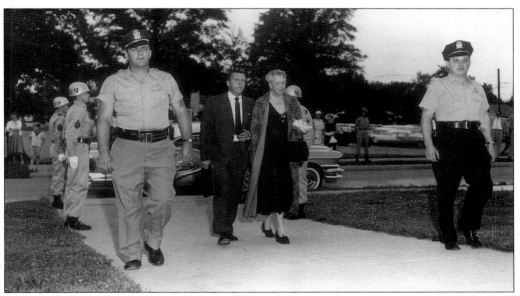

ELEANOR ROOSEVELT VISITS. On June 16, 1958, former First Lady and United Nations Ambassador Eleanor Roosevelt paid a visit to Clarksville High School to attend the annual dinner of the Clark County Chamber of Commerce. Shown with Mrs. Roosevelt is Dan Bottorff, Executive Secretary of the Chamber. Clarksville Sheriff Woody Gilbert is the policeman on the left. The gentlemen on the right is unidentified. Supreme Court Justice Sherman Minton, a New Albany native, also attended the dinner.

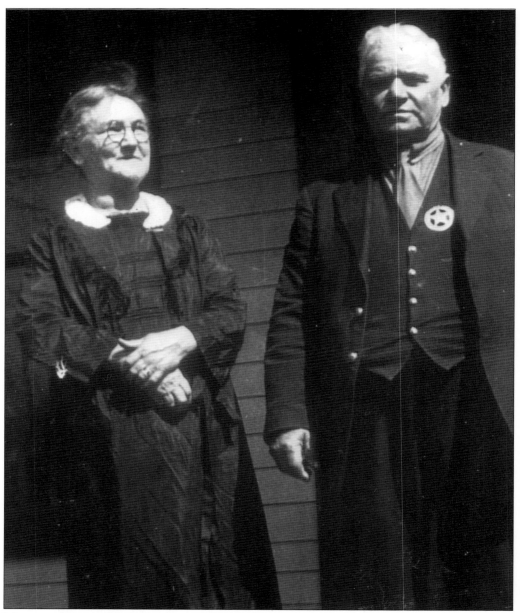

MARSHAL YATES. Pictured is Samuel Yates, who was town marshal about 1900, with his wife. Clarksville began hiring men for security in January of 1791, when the town board approved money from the sale of lots to be used to pay six men for defense of the town. In the spring of 1793, John Harrison had hired two men to "guard or spy around the town". John Burge was paid £12 for providing the service and Mrs. Andrew Heth and Captain Robert George were paid £12 for boarding the spies.

On May 25, 1835, Thomas Carr was paid for services rendered the town board as sheriff. He was still serving in that capacity in 1852, and was paid $252 that year. By 1864 the board was hiring the Jeffersonville Marshal to serve notices concerning the opening of streets, so they apparently managed during that period without a full-time security officer.

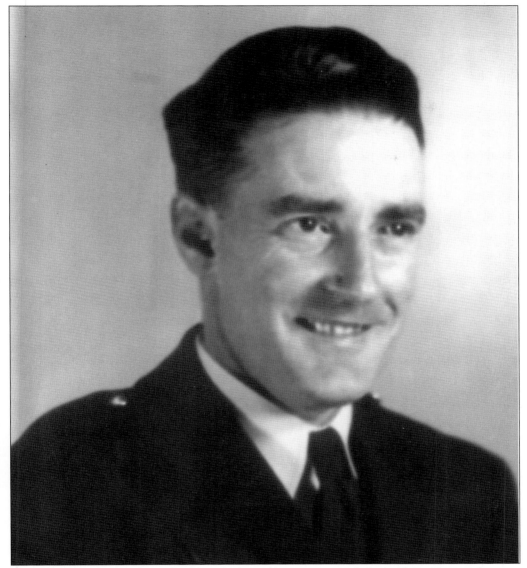

RALPH McCULLOCH. McCulloch took the job as town marshal in 1940. He was born in 1907 and was a lifelong resident of Clark County. A good athlete, he earned four letters in high school baseball, football, track, and basketball at Jeffersonville High School. In 1935, Mac made the All-Star Team in a local commercial league. In 1938, he was awarded the All-Louisville Baseball League Award.

He followed Roy Cole as town marshal in 1940 and served in that job for 13 years. "Mac" was known as a peacemaker, settling family disputes and restoring order following annual Halloween escapades. The young people in town respected him and knew they could count on him when they needed help. He was an athlete and a sportsman, coaching and managing Little League teams in the 1940s and 50s. An avid hunter and fisherman, Mac and other Clarksville friends went yearly to South Dakota to hunt pheasant. After his stint as town marshal, he worked as superintendent of Walnut Ridge Cemetery until his retirement in 1953. Ralph McCulloch died in 1994 at 87 years of age.

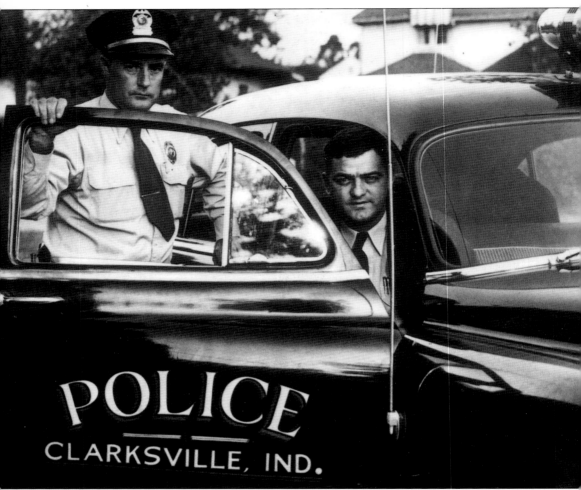

THE FIRST POLICE CAR. Pictured in 1944 are Sheriff Ralph McCulloch and Deputy Woodrow Gilbert in the town's first police car, a Chevrolet. The town marshal worked out of his home until 1926, when the fire station was built and furnished room for that purpose. A home at Stansifer and Clark Boulevard was later converted to the town's first police station.

Woody was hired as the deputy marshal in 1947. Each man worked a 12-hour shift, 7 days a week, Mac on days and Woody on nights. When Marshal McCulloch retired in 1953, Woody took over the office. He started the school guard patrol, formed a youth council, and helped with Little League. He was a friend of animals and would sometimes stop traffic on the expressway at Randolph Avenue to let dogs across the intersection. One time it backfired, as the animal lived on the other side. He was elected Clark County Sheriff in 1962 and served two terms in that office. Soon after Woody died in 1997, the town's new police station, the first ever built for the purpose, was named in his honor.

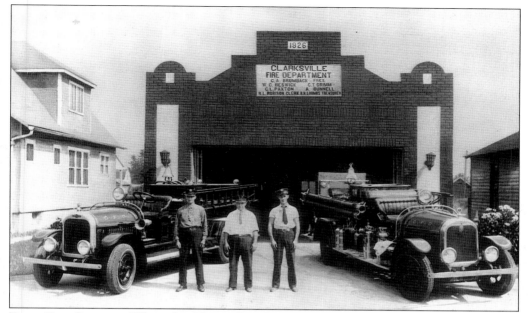

FIRST FIRE STATION. When the Ohio Falls School burned in 1925, fire protection had been a problem. The local newspaper reported that " fire apparatus installed by the town is of very little practical value and the fire department of Jeffersonville cannot respond to calls, being prohibited by action of the City Council." The next year the town built its first fire station on Stansifer Avenue.

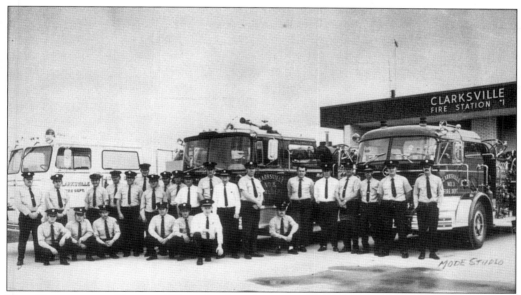

THE DEPARTMENT GROWS. When the first fire station was built, the Pennsylvania Railroad donated two trucks to the department, one chemical truck and one pumper. In 1962, the department consisted of seven people and a second fire house was built. By 1974, there were three modern trucks and a significant increase in personnel.

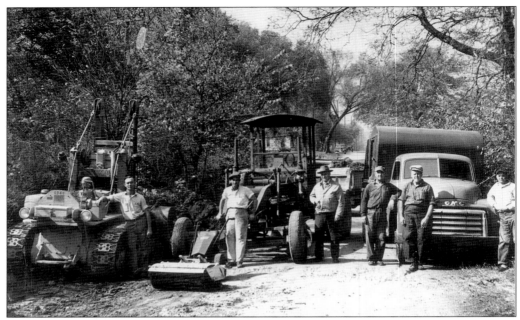

STREET DEPARTMENT. Formed in the 1940s, Robert "Skeets" Riggle (on left) was the first superintendent. Joe Graninger, Roy Cole, Oscar Huff, Steve Mullen and John McGuiggan succeeded Riggle. Devotion to the town's welfare became evident when, in the early days, the men worked on credit because the town was sometimes unable to pay their salaries. Pictured, from left to right, are as follows: Robert Riggle, Thomas Varble, Joe Graninger, Carl Pearcy, Frank Louden, street department employees, and Bernie Dobson, a businessman.

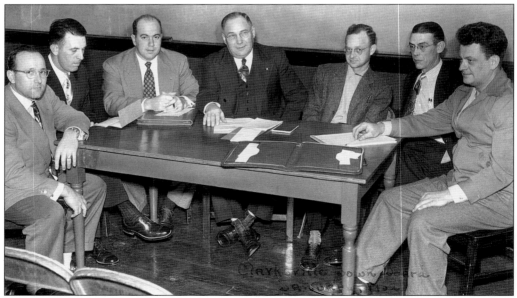

TOWN COUNCIL. Shown in January of 1952, from left to right, are town council members: Richard "Carpy" Baird, Herb Brumback, Clifford Maschmeyer, ? Smith, Edward Metzger, and Jim Robison.

ASSISTANT SUPERINTENDENT OF THE STREET DEPARTMENT. John Rogers is pictured on a grader on Randolph Avenue in 1948. He was assistant superintendent for over 42 years. John cut all the streets in Greenacres and made the first Little League ball diamonds. He remembers when Arlington Avenue was widened using stones from the old prison guard wall.

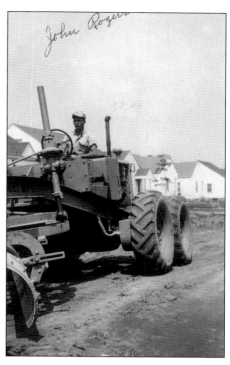

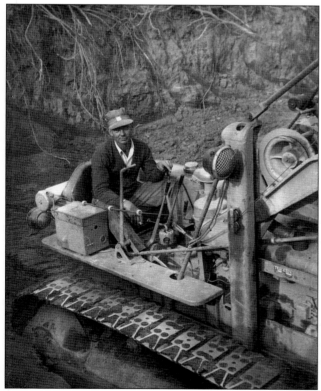

ROBERT RIGGLE. Shown digging the first Clarksville swimming pool in 1951, Riggle was manager of the street department. After the sewage disposal plant was built in 1952 he became superintendent of that facility. Clarksville was the first to conform to the order to stop stream pollution in the Falls Cities area. As manager, he did the work of a mechanic, inspector, administrator, gardener, chemist, tour guide, and public relations man. He built his home next door to the plant, so he could be closer to both his work and his family.

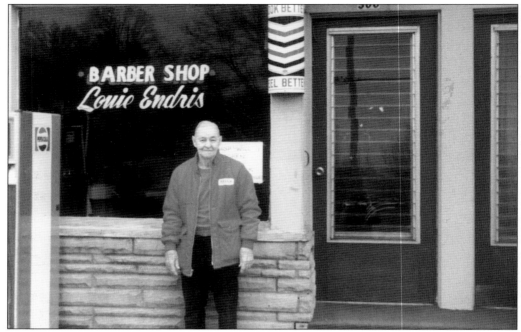

BARBER LOUIS ENDRIS. Louie Endris operated his barber shop on Stansifer Avenue for over 20 years. A kind man with a keen sense of humor, he would visit customers in the hospital, if needed. He cut hair for homebound invalids for many years. Louis was born in 1913 and retired in 1994 at the age of 81.

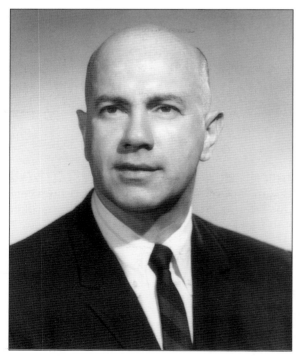

CLIFFORD H. MASCHMEYER. Maschmeyer served as attorney to the town in the 1950s. His political career began in the late-50s with his election as state senator for the district, which includes Clarksville. He was elected judge of the Clark Circuit Court in 1962 and served for 24 years. Maschmeyer lived on Norwood and on Altawood Drive in Clarksville.

Two

LEARNING

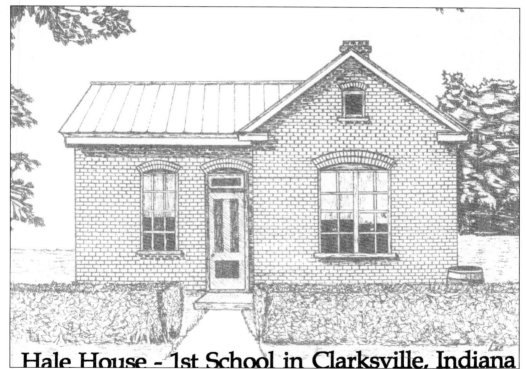

Hale House - 1st School in Clarksville, Indiana

THE FIRST SCHOOL. This drawing, labeled as the first school in Clarksville, is actually a home built from the bricks of the first school. Until recently, the home stood on a hill overlooking the site of the original town of Clarksville. It was demolished in 2000. The town's first school was built about 1861 on lot 19 at the corner of Jackson Street and Croghan Avenue. On November 27, 1867, Clarksville citizen Mr. Kelly appeared before the town board asking for an appropriation to pay the salary of a schoolteacher then teaching in the school. The board appropriated $75 for that purpose.

The old school was torn down around the turn of the century, and the bricks were used to build the home, pictured here, of the Hale family in 1900. A child of that family, Peter Hale, lived into his 90s, and, in an interview with a member of the Clarksville History Society, stated that "the bricks were carried up the hill" by him and his family. Several of the bricks were salvaged, and are in the Clarksville History Society Museum.

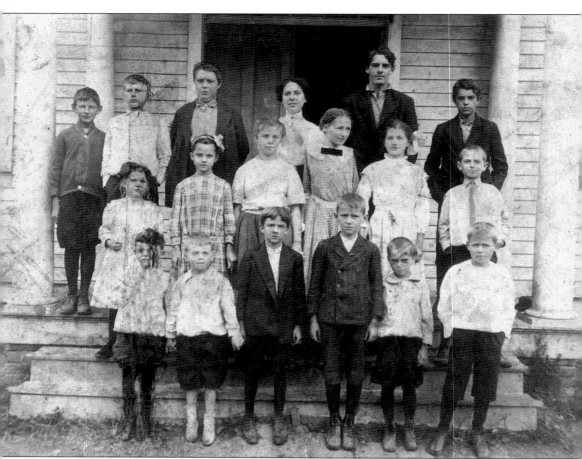

MCBRIDE SCHOOL. This one-room school was located on Blackiston's Mill Road, just north of the Blackiston Heights subdivision. It is not known when it was built, but was replaced in 1915 by McCulloch School. This photo was taken *c.* 1913. Miss Pearl Henderson was the teacher. One of the boys in the front row is Arthur Long; the others are not identified.

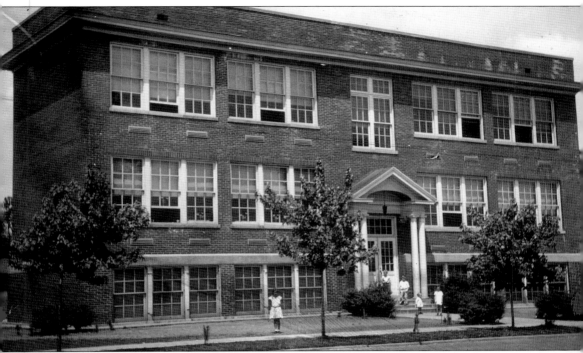

COLGATE SCHOOL. In 1872, Clarksville citizens petitioned the town board to build a school in the upper part of town. The only school at the time was the one on lot 19 of the original town site. By 1876, a two-story wooden schoolhouse had been built in the field across from the prison. This first Ohio Falls school had been abandoned by the 1890s and a new Ohio Falls school, two-story and made of yellow brick was built at the corner of State and Montgomery Streets. It was destroyed by fire on the last day of January 1925. The Colgate-Palmolive Company, which was in the process of re-designing and adapting the old prison into a soap-making plant, provided classrooms for the displaced students in the prison hospital. They were taken to and from their classroom by guards.

The new school, pictured above before 1930, was built on the same site and named "Colgate School" in recognition of the company's generous assistance to the community. It closed at the end of the 1975 school year, and for several years the building was used as the Clarksville Town Hall. It is now privately owned.

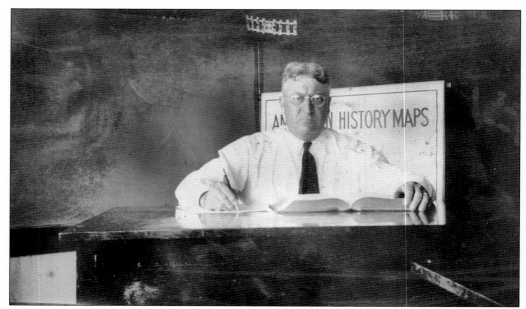

JOHN BROCK. Albert Mead had been principal during the 1920s, when the old Ohio Falls School burned and was replaced by Colgate school. John Brock succeeded Mead as principal and teacher of the seventh and eight grades. He was serving in that position when he died in 1951.

RALPH BAIRD. Baird became principal at Colgate School in 1951. He served at Colgate for 17 years. During several of those years he was principal both at Colgate and George Rogers Clark. When he left the Clarksville schools, Mr. Baird served for a time with the Greater Clark School in Jeffersonville before retiring in 1978.

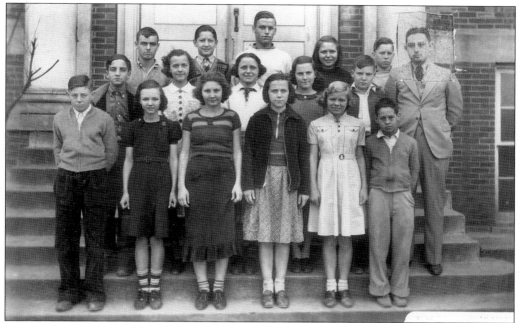

COLGATE SCHOOL SEVENTH GRADERS. These students are shown in 1938. They are, from left to right, as follows: (front row) Billy Boehm, Georgie Goodhue, ? Williams, Marjorie Wilcoxon, Mickey Inzer, Billy Biesel, and teacher Paul Moser; (middle row) Cecil Smith, Eloise Shelton, Marilyn Cain, Nora Varble, and Donald Baron; (back row) Leon Casey, Norman Kratz, Lawrence Casey, Mary Robbins, and Charles Miller. Teacher Paul Moser went on to become superintendent of schools for the Clarksville system.

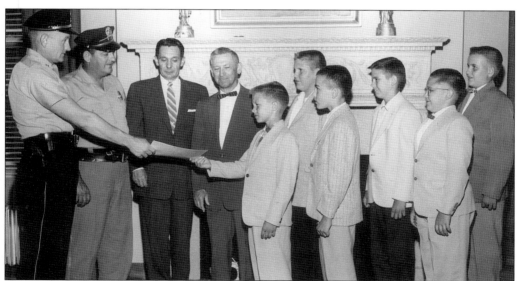

COLGATE SCHOOL, YEAR UNKNOWN. Marshal Woodrow Gilbert, second from left, and Principal Ralph Baird, third from left, are shown with Colgate students. The students appear to be receiving a safety award. It may have been for participating in the crossing guard program, since Clarksville schools were among the first to have that program.

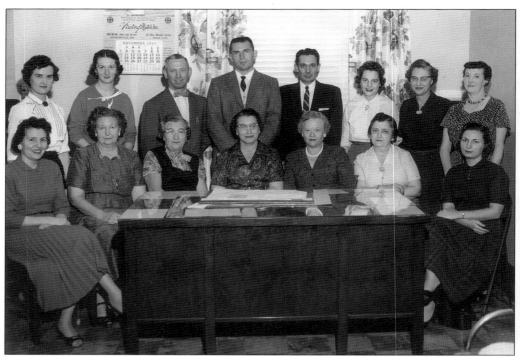

THE FACULTY OF COLGATE SCHOOL IN 1957. Principal Ralph Baird is shown fourth from right in the back row.

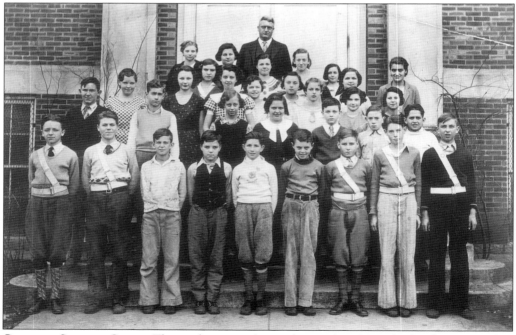

COLGATE SCHOOL CLASS. The students are shown during the 1934-35 school year. Teacher John Brock is shown with unidentified students.

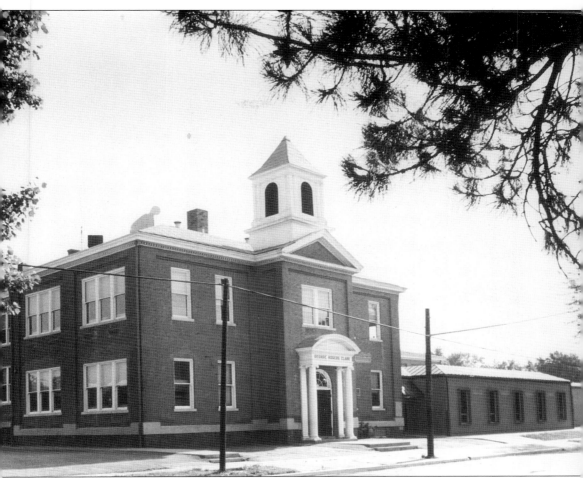

GEORGE ROGERS CLARK SCHOOL. Usually known as "GRC," the original structure was a two-story brick building erected more than a hundred years ago. It was built in 1899 on what was then Ely (now Stansifer Avenue). First called Howard Park School, the name was changed in the 1929-30 school year in honor of the famous Revolutionary War hero who made Clarksville his home. During the last century many changes were made in the facility. Major construction took place in 1975 when all but the original gymnasium was demolished and the present structure was built.

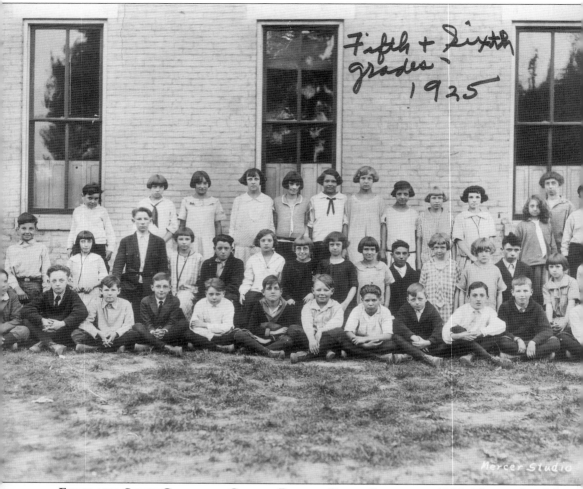

FIFTH AND SIXTH GRADES OF GEORGE ROGERS CLARK SCHOOL IN 1925. The teacher, Mrs. Edith Brouillard, is in front of the window. Students, from left to right, are as follows: (front row) Walter Rumpel, Delmar Kratz, Arthur Garden, John Grimm, Harry Rankin, Harry Cox, Orville Rumpel, Henry Hendrickson, Charles Logsdon, Earl Eadens, unidentified boy, and Elmo Inzer; (middle row) Elmer Coomer, Elizabeth Brothers, Howard Bratcher, Rowena Lewis, Laurence Sommerville, Edna M. Barkman, Ida Mae Hempel, Katherine Wallace, Carrie E. Leonard, Harry Akers, Ruth Straw, Dorothy Fields, Charles Brothers, Dorothy Coomer, and Lula Sutton; (back row) Norman Stein, Ruby Suddath, Elnora Leonard, Hazel Taylor, Mildred Hale, Katherine Gelbach, Mattie Bratcher, Ruby Taylor, Dorothy Mane, Frances Munz, Hazel Snyder, and Louis Snyder.

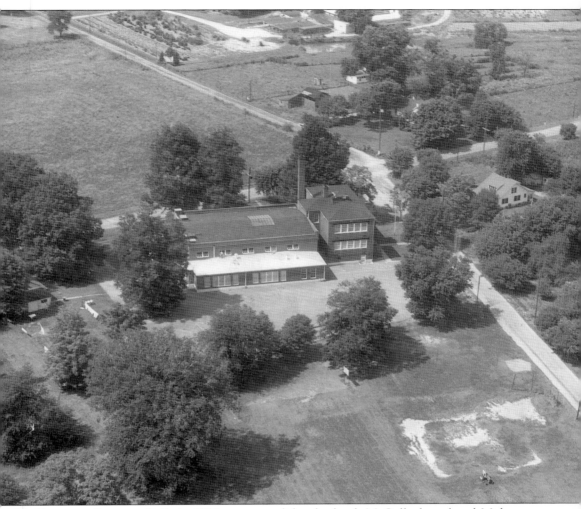

McCulloch School. Built in 1925 as a consolidated school, McCulloch replaced Midway, McBride, Asbury, and Cementville Schools. The land for the school was donated by Edward McCulloch and his wife Jennie. The building was erected by Robert Schiller & Son at a cost of $12,000, and was located next to McCulloch Chapel at Gravel Road, now Triangle Drive. It was two-stories high and had a large assembly room with a stage. There were three classrooms as well as two basement rooms, which were planned for teaching agriculture and domestic science.

Claude Whelan was the first principal and Margaret Sweeney and Edith Smith were his assistants. Miss Sweeney was in charge of the domestic science course. Herman Shoemaker was building custodian. Charles Graham donated the landscaping for the school. A covered wagon, which had glass sides, was purchased to haul children of outlying neighborhoods to the school. The gymnasium and four additional rooms were added in 1936. During the 1937 flood the building housed refugees. The school closed in 1992 and the building was demolished in July 1994.

McCulloch Principal. Dolly Carter is shown in north side of the schoolyard. She spent 20 years at McCulloch as both principal and teacher. Robert Johnson had been principal in the early 1930s. Following Ms. Carter, Norman Lewis was principal for many years.

Students at McCulloch School. Pictured are Elizabeth Shoup and Jane Brown in the schoolyard about 1945. Other students are unknown. The school had been remodeled in 1957-58. Teachers about this time were Paul Hottell, Laura Daugherty, Harriett Stalker, Grace Scamahorn, and Olive Payne.

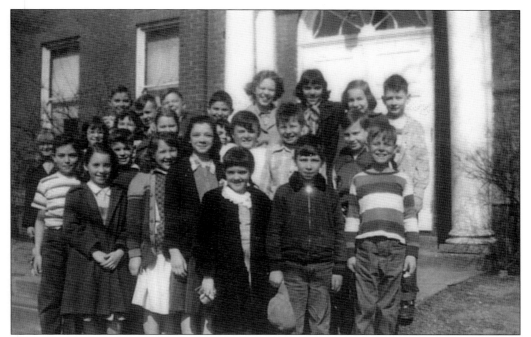

FIFTH GRADE, GRC SCHOOL. This is Libby Baird's class in the 1950-51 school year. They are, from left to right, as follows: (front row) Sharon Bega, Sharon Wohrle, Beatrice ?, Laurice Tetley, David Coats, and Billy K. Murphy; (second row) Bobby Strauth, David Colvin, David Rauth, unknown, and Benny Hester; (third row) Carol Cummins, two unidentied children, Anne Applegate, and Sherry Jackson; (back row) Harry Thompson, Randall Baird, Larry Abbott, Lydia Sue Combs, Sandra Howland, Marilyn Strother, and Jimmy Patterson.

THE CLARKSVILLE HIGH SCHOOL BAND. The year is unknown. The Clarksville band was organized in the fall of 1955. Until 1957 the school had only seventh, eighth, and ninth grades. In 1959 the band had 65 members and was uniformed for the first time. The director was Mr. Marshall Neely, who led the band for many years.

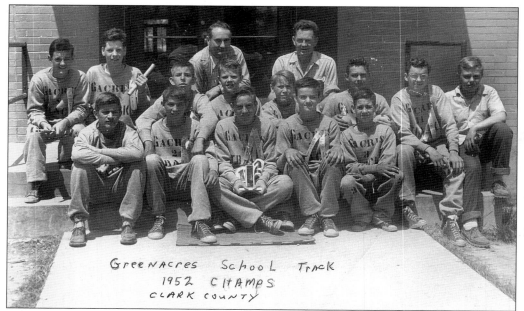

GREENACRES TRACK CHAMPS. Shown in 1952 (last names only), from left to right, are as follows: (front row) Cunningham, Toler, Anderson, Sandlewich, and McNickle; (middle row) Snider, Sellmer, Landis, Graver, Endicott, Inzer, Cottrell, and Wallbridge; (back row) Mr. Jones and Mr. Temple. Greenacres Elementary School was built in 1949.

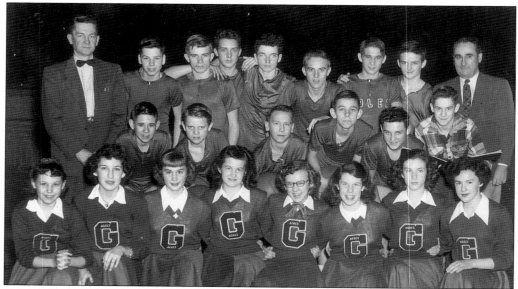

GREENACRES EIGHTH GRADE BASKETBALL TEAM. The team is shown in the 1952 season. Cheerleaders, from left to right (last names only), are as follows: (front row) Tunner, Sellmer, Cunningham, Inzer, Cottrell, Anderson, Toler, Sandlewich, and Jones; (middle row, basketball-team members) McNickle, Graver, Endicott, Landis, Snider, and Summers; (back row) Tunner, Cooke, Isgrigg, Legg, Hudgin, Worden, and Roy. Mr. Jones is on the left and Mr. Temple are on the right end of the back row.

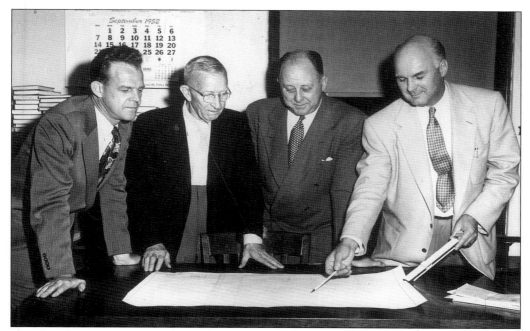

CLARKSVILLE HIGH SCHOOL PLANS. Members of the Clarksville School Board are shown conferring with the architect in 1952, prior to the building of the high school. Until that time, Clarksville students went to either Jeffersonville or New Albany High School. Board members, from left to right, are Winford Walker, J.W. Hume, and E. Bunnell. The architect is unidentified.

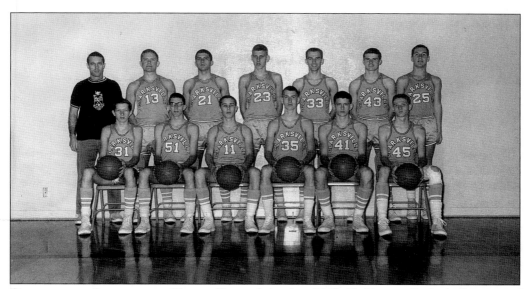

CLARKSVILLE BASKETBALL TEAM. Pictured is the 1965-66 Varsity Basketball team of Clarksville High School. From left to right, they are as follows: (front row) Rick Foster, Herb Schlageter, Dennis Barry, Jim Kelly, Tom Turner, and Steve Harper; (back row) Jack Haury (head coach), Monty Spencer, John Lopp, Bernie Jackson, Jack Dewees, Leon Stocksdale, and John Franklin.

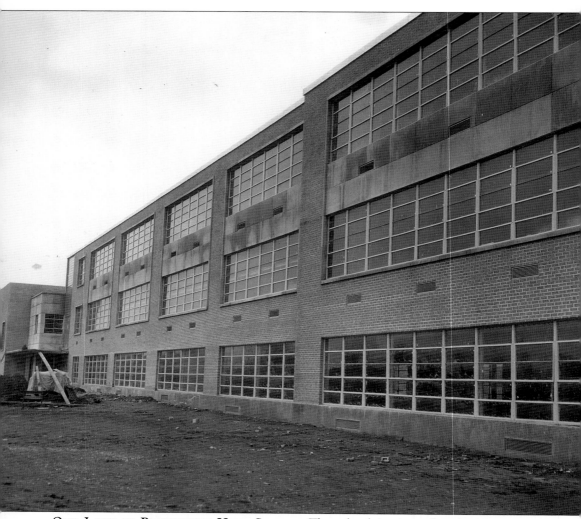

OUR LADY OF PROVIDENCE HIGH SCHOOL. The school is pictured under construction in 1951. The school is an inter-parochial and co-educational school, which serves several counties in Southern Indiana. It is located on old Highway 131 near the Centralia neighborhood of Clarksville. It was originally in charge of the Congregation of the Sisters of Providence, which has had its headquarters at St. Mary-of-the-Woods, Indiana, since 1840. Ground was broken for the school on March 21, 1951, and Providence opened its doors for its first freshman class on September 12, 1951. The 137 students of this first class came from 11 different parishes around Clark, Floyd, and Harrison Counties. In 1989 Providence began accepting Junior High Students. Ninety-five percent of the schools graduates pursue post-secondary education. The school offers a full range of intercollegiate sports and is a traditional rival of Clarksville High School in football, basketball, and baseball. (Courtesy of the *Louisville Courier-Journal*)

Three

WORSHIPPING

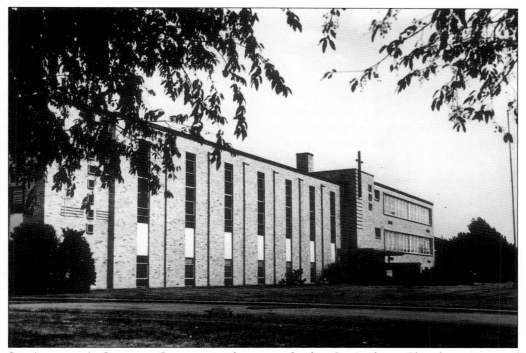

ST. ANTHONY'S CHURCH. Construction began on the first St. Anthony Church in August of 1851. It was a small brick structure, 25-by-50 feet. In 1876 a new church was built at the corner of Maple and Wall in Jeffersonville. By 1946, Clarksville's population was beginning to increase sufficiently that the need to serve this new population became apparent, so it was decided to relocate the church there. Seven acres of land was purchased and construction of the new school, church, and convent began in April of 1949.

The church and school were in either end of one main building. The school opened for classes that fall, but the church portion of the main building and the detached convent opened a few weeks later. An old two-story house on the property was converted to a friary.

On May 12, 1970, lightening struck the church and set it afire. It happened during school hours, but the building was constructed with a firewall between the two wings, and the school did not burn. Until the new church was built, services were held in the gymnasium of Providence High School. St. Anthony's present church was dedicated on May 23, 1972.

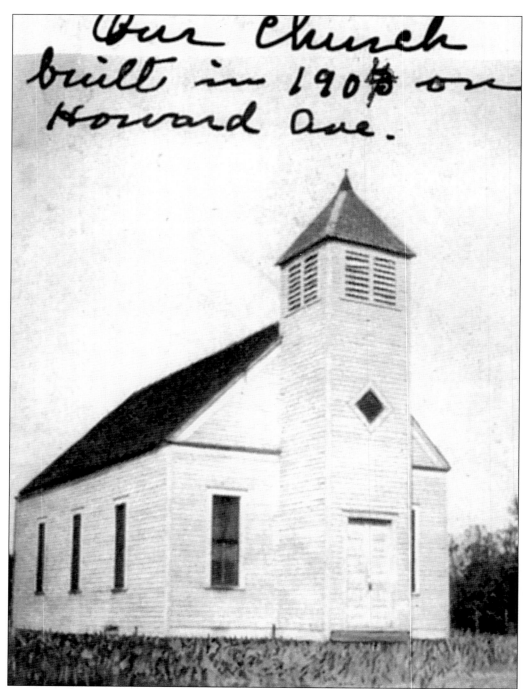

THE FIRST HOWARD PARK CHRISTIAN CHURCH. Built in 1904, the first Howard Park Christian Church was organized in 1903 with 25 charter members. Three of those were still alive in 1953: Reverend Max Wilson, Mrs. Libby Patterson Durrett, and Mr. Robert Robison. The first meetings were held in the George Rogers Clark School. The church was built on ground donated by the Howard Park Development Company

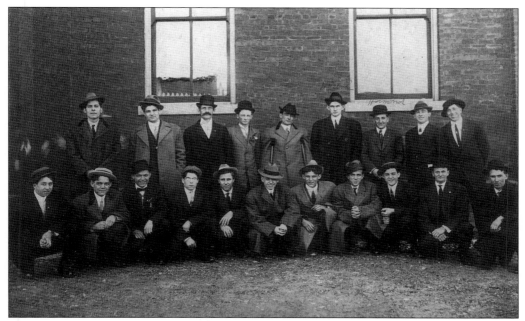

THE ROYAL SONS. A men's class of the Howard Park Christian Church is shown at the George Rogers Clark school in November of 1911. They are, from left to right, as follows: (front row) Lewis Detrick, Edward Hollowell, Lawrence Mayfield, Robert Tharp, Pat Stites, Howard Welker, Roy Hollowell, Clyde Welker, Herman Hollowell, Robert Robison, and Grover Waisner; (back row) Victor Beutel, Claude Hollowell, Reverend Coyle, Charles Plot, George Munz, Leland Howell, George Hammond, Ray Hambough, and Frank Fleenor.

MEN'S SUNDAY SCHOOL CLASS. The men's Sunday school class is shown at the original Howard Park Church in 1914. Elmer Detrick and Louis Detrick are the only ones named in the photograph.

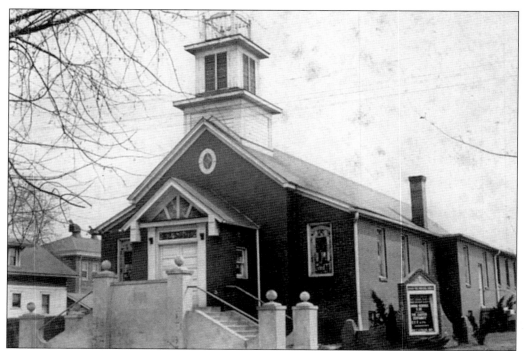

HOWARD PARK CHRISTIAN CHURCH. The church moved to a larger building at the present location at Norwood and Park on April 19, 1926. Membership continued to grow and an education building was added in 1954. The entrance and sanctuary were remodeled in 1971.

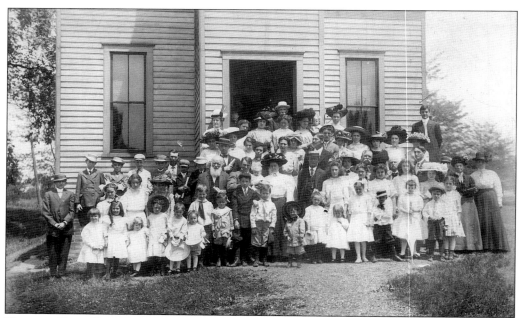

HOWARD PARK CONGREGATION. This photo of the members of Howard Park Christian Church was taken in front of the original building on Howard Avenue about 1910. The individuals are unidentified.

OHIO FALLS METHODIST CHURCH. The church began as the Wesley Chapel Methodist Episcopal Church early in the 1880s as a mission of the Wall Street Methodist Church. Members first met in the Car Foundry lumberyard, just south of the old prison. A church was built on the southeast corner of what is now Clark Boulevard and Beckett, but was destroyed by a windstorm about 1890. The land was traded for a lot on Virginia Avenue. By 1893, a building had been placed on the site and a dedication service held. The name was changed to Ohio Falls United Methodist Church on June 1, 1968.

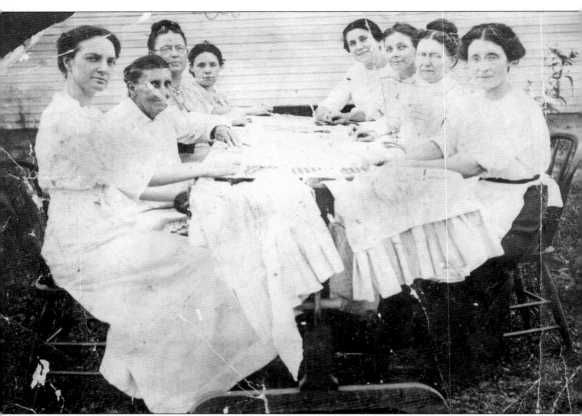

HARRISON AVENUE METHODIST CHURCH. The Women's Auxiliary Club is pictured here at an unknown date. The church began in 1893 as a mission of the Wall Street Methodist Church in Jeffersonville. At first it was called the Howard Park Methodist Church and services were held in a cottage on Kenwood. It is not known when the name was changed. On October 14, 1894, services were held in a new building in Clarksville. The present building was completed in November of 1969.

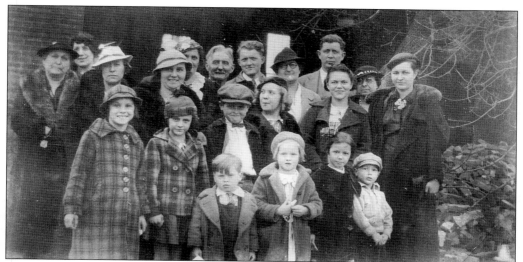

THE CONGREGATION OF THE MCCULLOCH CHAPEL IN 1937. The Church was built as a non-denominational chapel prior to the 1870s on land donated by John McCulloch. It fronted on the New Albany and Charlestown Pike, later known as McCulloch Pike, which today is State Highway 131. Nineteen thirty-seven flood damage can be seen in the background. The state widened the highway to four lanes in 1966 and the chapel lost some ground to the highway.

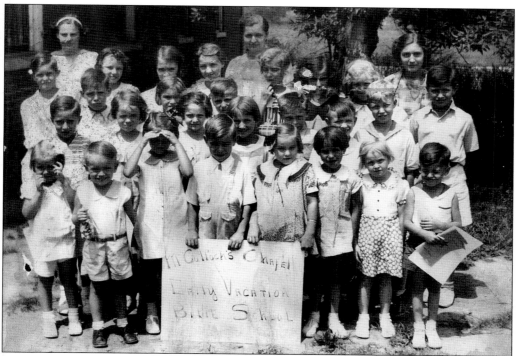

MCCULLOCH CHAPEL VACATION BIBLE SCHOOL. The photo is from about 1936 and the people are not identified. It was shortly afterward that the flood badly damaged the building. A descendant of the McCulloch congregation estimated that the chapel was torn down in the mid-1950s.

FIRST SOUTHERN BAPTIST CHURCH. The church was organized as the First Missionary Baptist Church in 1948. The congregation of 26 people first met in the home of Pastor Robert Weyler. In 1949 services were held in a vacant garage before moving to the non-denominational McCulloch Chapel. It became the First Southern Baptist Church of Clarksville in January of 1951, the same year that land was purchased on Ettel's Lane for a new building. Dedicated on June 6, 1954, it was destroyed by fire in 1969. Until a new sanctuary was built, the congregation met at the Clarksville High School Auditorium. The present church was dedicated on June 24, 1970.

Four

WORKING

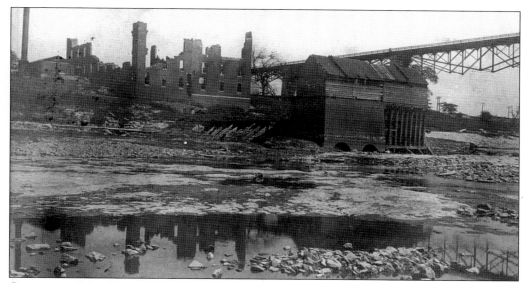

GATHRIGHT MILL RUINS. In 1853 a flour mill was built by Mr. Smith and Mr. Smyser upstream from where the Pennsylvania Bridge would later stand. It operated through the Civil War, but burned on August 2, 1870. R.O. Gathright purchased the remnants of the mill and built the one pictured above in late 1870. Constructed of brick, it was four stories high and had a second smaller building in the river alongside the millrace.

Mills were an important feature of Clarksville's early commerce. One of the earliest was that of George Rogers Clark, located just beyond the fork of Mill Creek. The general was not a successful businessman and soon sold it. When the General's home was torn down in 1854, the Bullitt Mill was built on the site. The Fetter & Hughes Mill, built on the riverbank by 1816, was washed away by the great flood of 1832. A grist and sawmill was built at the mouth of Silver Creek before 1838. It was still standing into the late 1800s. Another early mill was the Long Mill on Cane Run Creek. It ran until 1840.

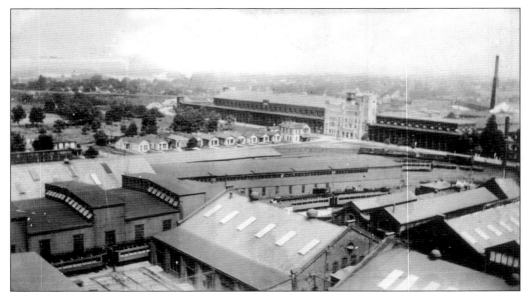

THE "CAR WORKS." Pictured in 1922 is the American Car and Foundry Company (foreground). The company began operations on June 1, 1864, as the Ohio Falls Car and Locomotive Company. Newly built passenger railroad cars are lined up alongside the buildings. The prison and its white main entrance can be seen in the background.

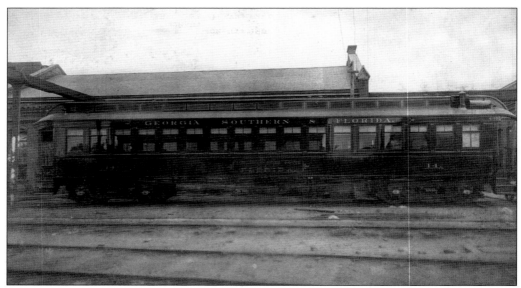

GEORGE, SOUTHERN & FLORIDA RAILROAD CAR. This newly built car is shown in front of the brick building of the Ohio Falls Car Company. The date is unknown, but is before 1900. The original cars were made of wood, but beginning in 1909, steel passenger cars began to be the standard of the industry

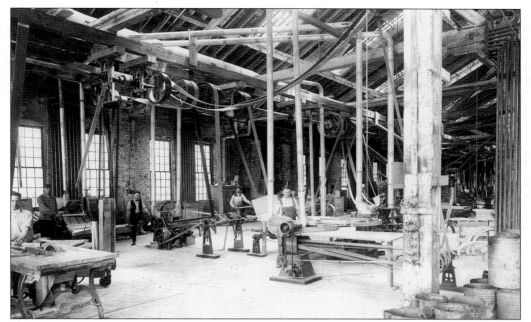

AMERICAN CAR & FOUNDRY COMPANY. The men working in this interior photo of the Car Foundry are not identified. The 1864 facility was virtually destroyed in a fire in 1872. It was rebuilt and reorganized in the late 1870s. In 1899, the company's name was changed to the American Car & Foundry Company.

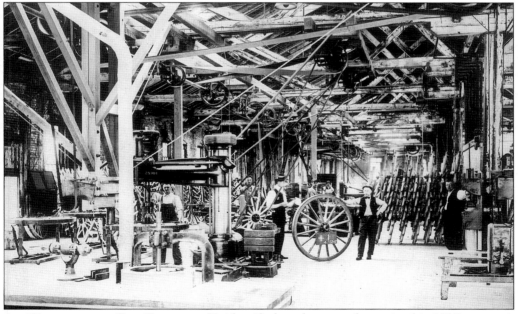

AT WORK IN THE CAR FOUNDRY. Unidentified workers are shown in this 1917 scene. A foreman, Mr. McDermott, is believed to be the man on the right. During World War I, the Clarksville plant made many military items, such as helmets, wagons, baking pans, tables, tent poles, and cots.

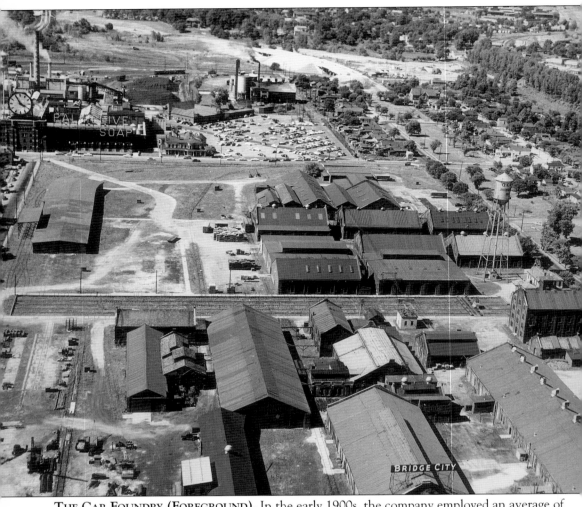

THE CAR FOUNDRY (FOREGROUND). In the early 1900s, the company employed an average of 700 men and produced at the rate of one railroad car per day. Output of the factory included coaches, parlor cars, baggage and mail cars, and private cars of the wealthy industrialists of the east. In 1933 the Car Works closed, a victim of the nationwide depression and of the country's growing reliance on automobile transportation. For many years the complex served varied uses such as warehousing and retail outlet stores. At the turn of the 21st century the historic buildings are being restored and renovated into offices and meeting facilities. The Colgate plant can be seen in the background.

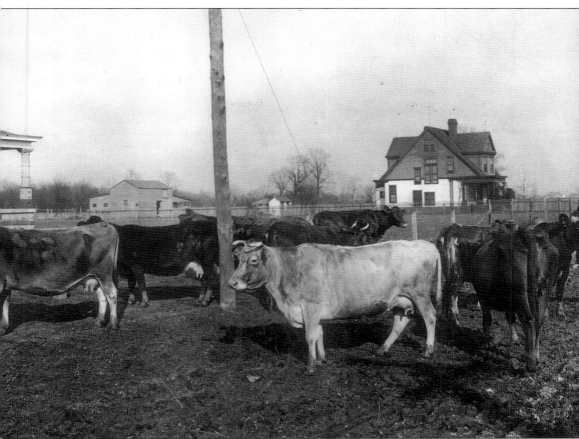

THE BAIRD DAIRY IN 1905. The Dairy, pictured at its location at the corner of Randolph and Harrison Avenues, began and thrived as a small dairy farm and processor. It was the first in the area to pasteurize milk. In the 1920s, ice cream manufacturing was added. The milk production operation was phased out after a few years. Their product was originally known as Clark County Ice Cream, but later was changed to Baird Ice Cream. The home on the left is still occupied.

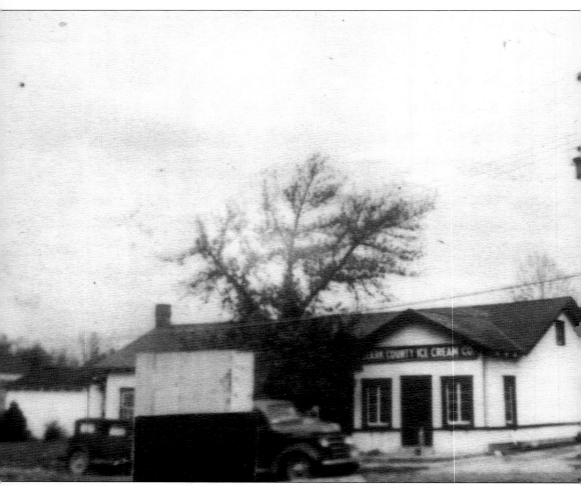

BAIRD DAIRY COMPANY. Shown here in 1930, Baird's Dairy was founded in 1904 and is the oldest continuing family business in the area. This building has been covered by brick and is still the headquarters of the business. Founded by James Patterson Baird, it is presently owned and operated by his grandson, Randall Baird. James Baird's wife, Amy Schuler Baird and their eight children were all actively involved with the business for many years. The elder Baird died in 1980 at age 101.

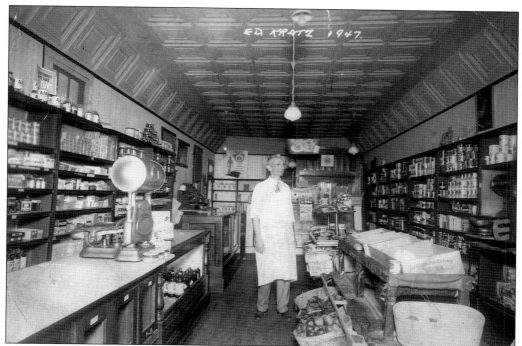

KRATZ'S GROCERY. Ed Kratz is seen standing in his grocery store in 1947. Born in 1894, Ed went into business for himself at the age of 18, making and selling ice cream in the Ohio Falls area of Clarksville. The business grew into a partnership between Ed and a Mr. Heckel. They stayed in business until 1936, when it became Kratz's Grocery. In 1947 Ed's son, Norman, took over the business and in 1955 it became the Kratz's Sporting Goods store that occupies the same building today.

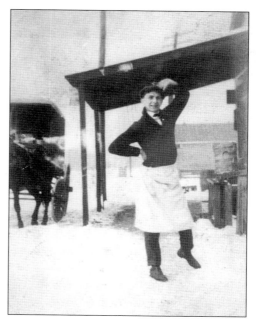

ED KRATZ. Shown in front of his store, Ed started his day at 4:00 a.m., going to the Louisville Haymarket for produce and returning to open his grocery at 6:00 a.m. He came home at 10:00 p.m. each night. During the 1937 flood Ed emptied his store to provide food for flood refugees, giving it all away. Much of it went to GRC school, where many stayed during the flood. In 1947, Ed was awarded the Clarksville Optimist Club's first "Outstanding Citizen Award."

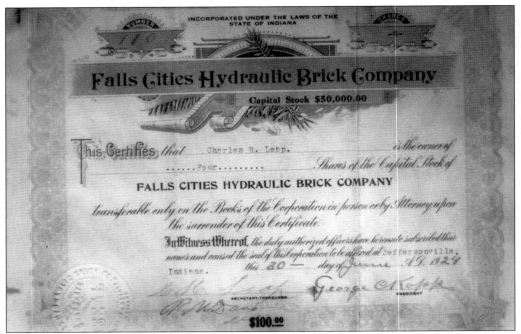

FALLS CITIES HYDRAULIC BRICK COMPANY STOCK. Located near Emery Crossing Road between the B&O railroad track and the old Pennsylvania railroad track, the company began making clay-building bricks in 1921. G.C. Kopp was president. Walter E. McCulloch, who sold the firm the land in 1919, was treasurer. The bricks were formed by a hydraulic type extrusion, using an underground tunnel drying system. The business ceased operations in 1925, probably because of the depletion of raw clay.

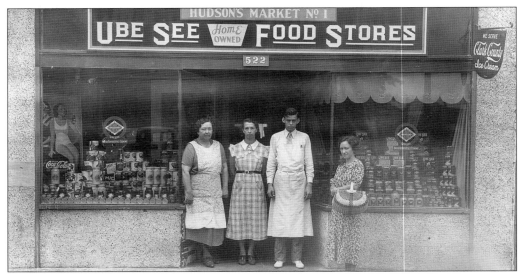

HUDSON'S GROCERY. Shown in late 1930s are Agnes Hudson, Thelma Hudson Garvey, Albert Holden, and Eunice Brown. Clarksville in the 1930s had a surprising number of grocery stores, sometimes almost next door to each other. There were at least six in the neighborhood known today as "Old Clarksville." Hudson's was located on Stansifer Avenue.

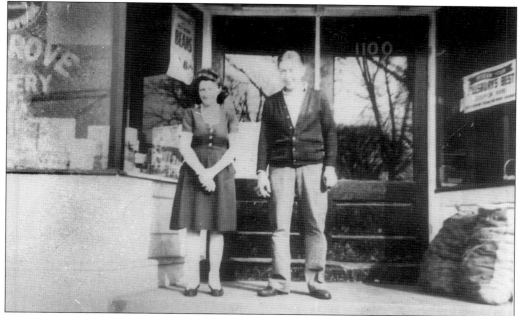

MOSGROVE'S GROCERY. Bill and Elva Mosgrove stand in front of their grocery store at the corner of Virginia and Winbourne Avenues. The Mosgroves bought the store, which had formerly been Ferguson's Grocery, in 1946. Another Clarksville grocery, Utz's, operated for many years at the corner of Stansifer and Clark Boulevard. The police station was later located in the building.

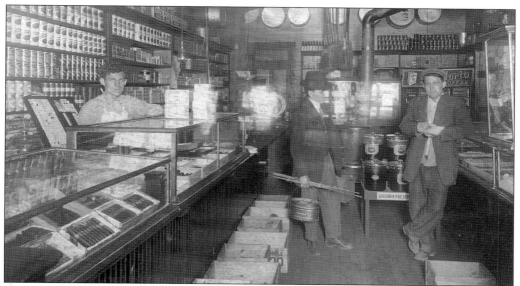

HOLLOWELL BROTHER'S GROCERY STORE. The store, at Stansifer Avenue and Clark Boulevard, is shown on September 3, 1909. Pictured, from left to right, are Roy Hollowell, Jack Yates, and Edward Hollowell. W.M. Reynolds operated a grocery store on Beckett Street for more than 50 years. The building was also the first Clarksville post office and Mr. Reynolds served as postmaster.

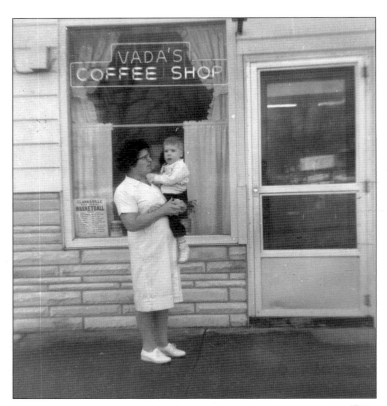

VADA GRANINGER. Pictured in front of Vada's Coffee Shop on Stansifer Avenue, she is holding her grandson, Alan Dale Edwards. John and Vada Graninger began their business in 1957 and continued until her death in 1973. More a restaurant than a coffee shop, Vada served a full menu of home-cooked meals. She remembered regular customers' likes and dislikes, and if you forgot your money, you could bring it in the following day.

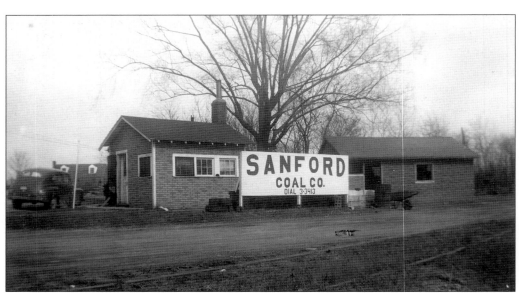

SANFORD COAL COMPANY. Originally the LaFollette Coal Company, Ernie Sanford bought the business about 1940. He operated the coal company until 1943, when his father, Joe, took over. Joe and Lily Sanford ran the business until the mid-1950s. It was located at 404 Clark Boulevard, today the location of the Lakeview Condominiums.

CLARKSVILLE FLOWER SHOP.
Juanita Curry began work at Cannon's Florist before opening her own florist shop on September 11, 1948. Her first shop was in Minnie Neal's building on Stansifer Avenue, shown in the photo. The business subsequently moved to her home on Oak Street.

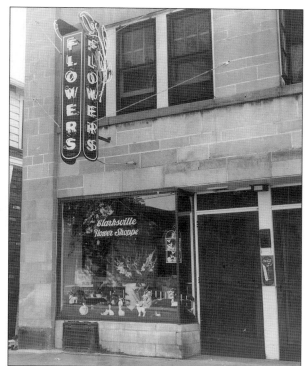

COLGATE-PALMOLIVE COMPANY.
The Colgate Company bought the Reformatory in 1921. For the first few months during the conversion into a soap-making operation, about half the inmates remained, living in the cellblock that was to become the laundry soap building. The first cake of Octagon soap was made on July 4, 1924.

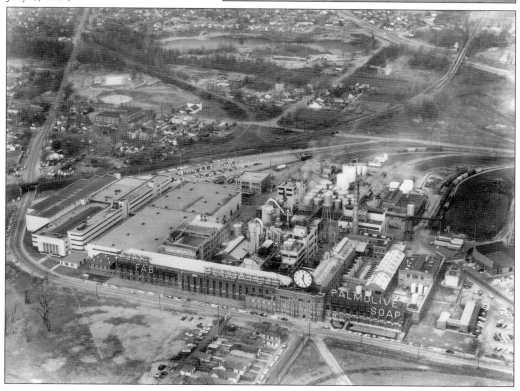

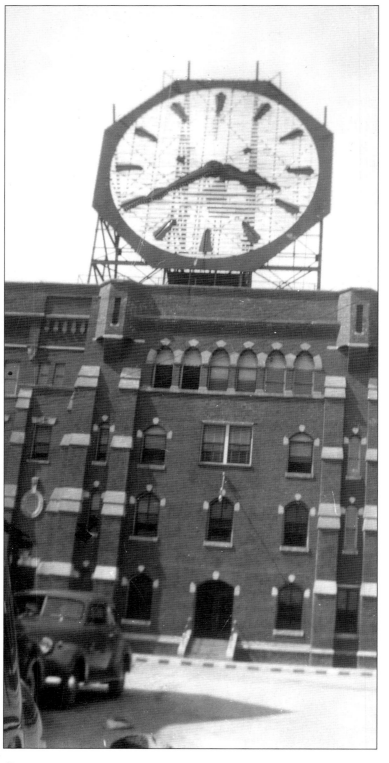

COLGATE CLOCK. The clock, said to be the second largest clock in the work, had originally been atop the Jersey City, New Jersey Colgate plant before being brought to Clarksville. It was replaced in New Jersey with an even larger one. The clock is almost 40 feet in diameter and is easily visible in downtown Louisville, one mile away. It was lighted for the first time on November 17, 1924, at the official opening of the plant. When the company first took over the prison, the workers converting it to a soap making operation were separated from the prisoners by a large wooden fence, which divided the facility in half. The possibility of prisoner's escape was increased by the circumstances, and at least one successful attempt was accomplished through the sewers to the Ohio River. The escapees nearly drowned in the attempt, but did get free. They were caught a year later. The last transfer of prisoners was made at the end of 1923, when the administrative offices and Mr. Shidler, the superintendent at the time, moved to the northern prison.

Five

GETTING AROUND

BAILEY STREET. The street looks today much as it did in 1800. When George Rogers Clark planned the town that was his namesake, he named many of the streets after men who had been in the small army with which he had won the west from the British. Montgomery, Todd, Bailey, and Harrison streets were all named for officers in the Illinois Regiment. The main street of the town was named Croghan Avenue for his brother-in-law, William Croghan.

The old Buffalo Trace, the path formed through the wilderness by the migrating Buffalo over the centuries, became the primary pioneer route west. It led to the only other early town of the western territory, Vincennes, so that was the name Clark gave to the street that followed it through town.

Many of the early records of the town deal with the problems associated with getting around. Many surveys were done for roads through the forests that surrounded the little town. William Clark laid out one road and designed a bridge to cross Mill Creek, which emptied into the Ohio River in the center of the town.

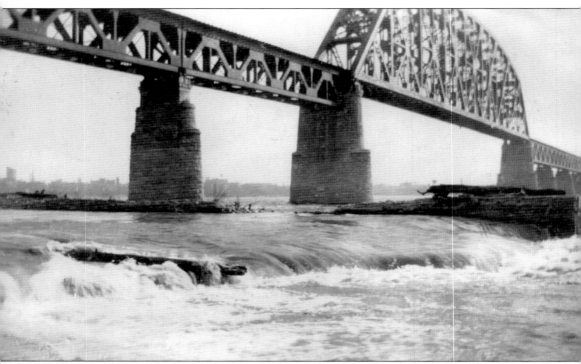

BRIDGE TO LOUISVILLE. As early as 1832, a project was started for a bridge to connect Indiana and Kentucky. Construction was begun in Clarksville but lack of funds soon brought a halt to the work. The Civil War brought about the first successful spanning of the local segment of the Ohio when temporary pontoon bridges were built to transport troops and war goods between the two states.

After the war, the Louisville and Nashville Railroad Company made plans to put up a permanent bridge. Albert Fink, a bridge builder of national reputation, was brought in and construction was underway by 1867. The bridge design incorporated a single span of 400 feet, which was the longest single span in the country at that time. The mile-long bridge took three years to build and cost the lives of 56 workers.

The Ohio River Railroad Bridge, also called the Louisville Bridge and later the Pennsylvania Bridge, was dedicated on February 18, 1870. The first train across carried 500 passengers and an immense crowd gathered to watch the event.

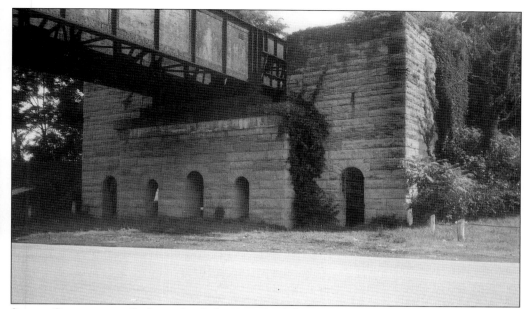

STONE STRUCTURE. Built at the Indiana end of the Pennsylvania Bridge as an office and storage area during construction of the bridge, it served as quarters for supervisory and design personnel. Its purpose has been largely forgotten and many stories have been told to explain its origins. One such story is that it was built as a fort to repel a Civil War invasion from the south. The story ignores the fact that the war was over before the bridge was built.

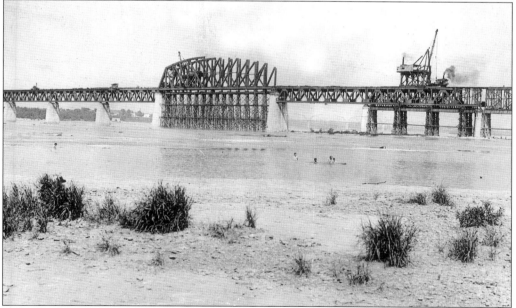

PENNSYLVANIA BRIDGE DURING RECONSTRUCTION. In 1916, renovations on the bridge were completed. New spans were placed on the original piers. The original bridge had a 6-foot wide walkway for pedestrians. In 1870 $1,045 were collected in tolls on the foot walk. It was removed during the renovation and today only train traffic is allowed. Note the swimmers in the river.

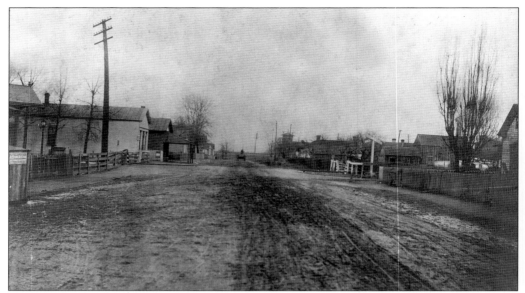

BECKETT AVENUE, LOOKING EAST. This picture, from the early 1900s, shows Beckett where it crosses what is now Clark Boulevard. The site of the original town had failed to flourish, and frequent flooding caused much of the population to move to higher ground. Developments in the 1870s concentrated in the area of the state prison and the Ohio Falls Car Works, such as Beckett, just north of both facilities.

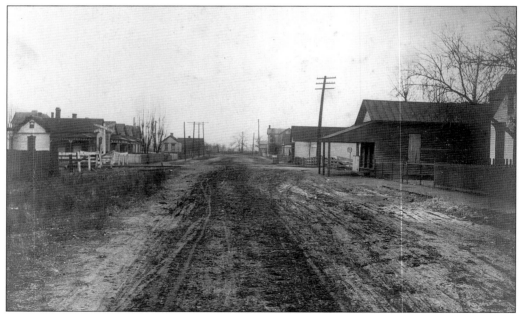

BECKETT AVENUE, LOOKING WEST. The crossing sign of the Dinky track can be seen at left center. Kratz's grocery is just beyond the dark building with the porch on the right. Howard Park and Ohio Falls were names given to neighborhoods in this area of Clarksville. In the early 20th century residents rarely named Clarksville as their home, giving instead the names of these neighborhoods.

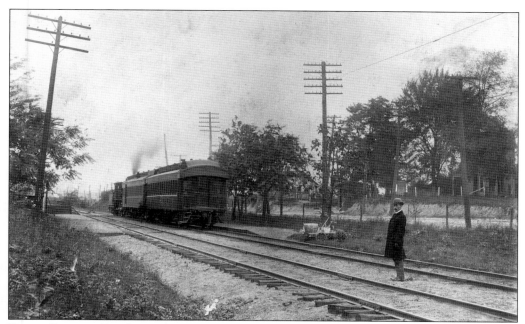

Dinky Passing By. Since there were no facilities to turn the train around, it went forward from New Albany to Jeffersonville and Louisville, and backward on the return trip. It took slightly over 30 minutes to make the trip from the New Albany station to Louisville.

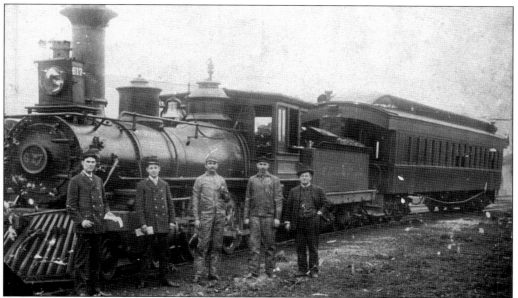

Dinky Engine #617. The official name of the Dinky was the Jeffersonville, Madison & Indianapolis Railway Company, but the local part of the line was immediately and ever after known as the Dinky because of its small engines. The railroad from Jeffersonville to New Albany was built in 1865. The company had purchased the old Plank Road between Jeffersonville and New Albany and laid its tracks in the roadbed after the planks were removed. The crew is unidentified.

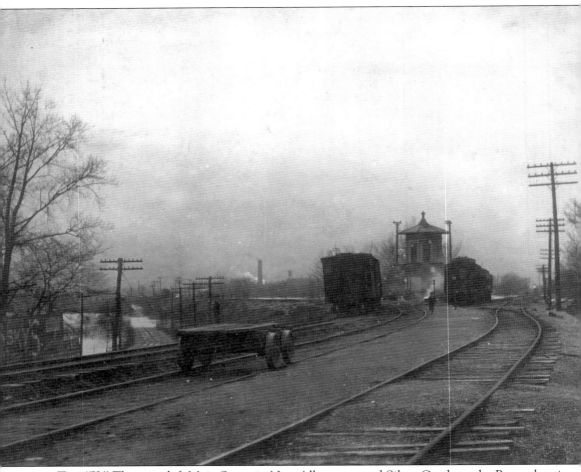

THE "Y." The train left Main Street in New Albany, crossed Silver Creek on the Pennsylvania Bridge, and continued to the Jeffersonville crossing. There the track split, one going south to the prison station and on to Louisville over the Louisville Bridge, the other swinging east into Jeffersonville. The "Y" in the tracks was just north west of the Indiana State Prison, at present-day Clark Boulevard and Arlington. The power plant tower of the prison can be seen to the left of the freight car.

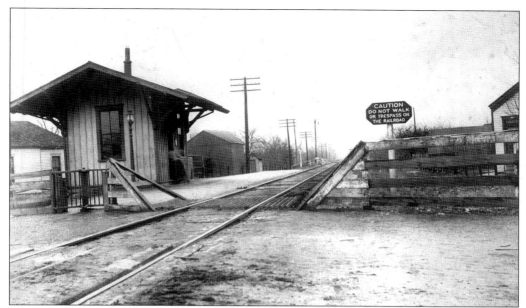

BECKETT STREET INTERSECTION, LOOKING NORTH. The sign says, "Caution. Do not walk or trespass on the railroad." At least one pedestrian was killed in a Dinky accident. In August of 1899 Valentine Kelly was about to walk across the railway bridge across Silver Creek on his way to New Albany, when he encountered an eastbound train. In stepping out of the way of it, he walked in front of the westbound train coming from the other direction. Kelly was born in Clarksville in 1827 and owned a large farm on the Ohio Riverfront.

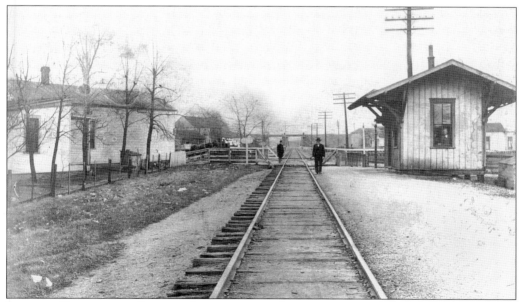

LOOKING SOUTH FROM BECKETT INTERSECTION. A station stop can be seen on the right. The Pennsylvania main line used the overpass seen in the background, which still stands today. Note the fence across the tracks. At that time, many of the homes kept a cow or two, or a few pigs. The fence kept animals from wandering onto the track.

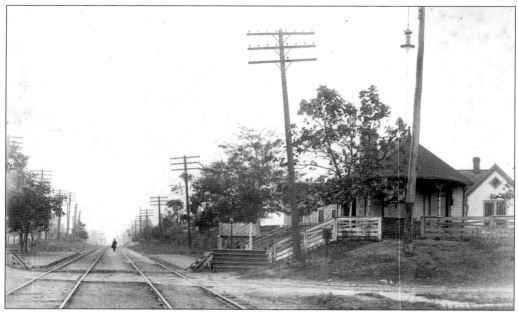

THE CROSSING OF STANSIFER AVENUE. A double track began at Howard Park and continued on to Jeffersonville. After the advent of personal auto transportation, the track was abandoned and the route was paved. This segment was turned over to the town in 1930 and designated as "Clark Boulevard," as it remains today

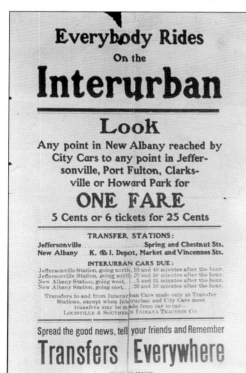

INTERURBAN AD. The Interurban began in 1903 as the Louisville and Southern Indiana Traction Company, controlled by utilities magnate, Samuel Insull. The Interurban was bigger and faster than the Dinky, and ran on electricity. The wide sections of Stansifer Avenue and Lincoln Boulevard (at Lakeview) identify where double switch track was laid. The company name was later changed to the Interstate Public Service Co. and then to Public Service Company of Indiana.

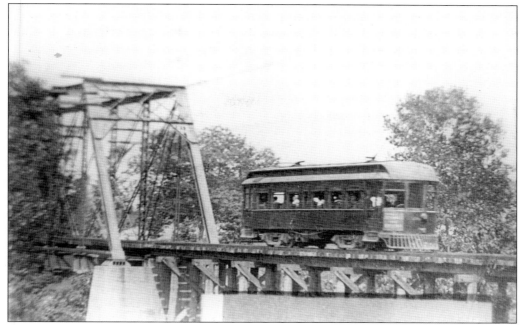

CROSSING THE SILVER CREEK BRIDGE. The Interurban connected with another electric railroad line which went to Indianapolis and northern Indiana. Stations in Clarksville were Silverton, Emery's Crossing, Brown's Station, McCulloch's Crossing, Midway, Rosedale, Howard Park, and Stansifer Avenue. Insull's bubble burst with the 1929 Wall Street crash and the line went bankrupt in 1933. A bus route began in 1934, using much the same route as the Interurban.

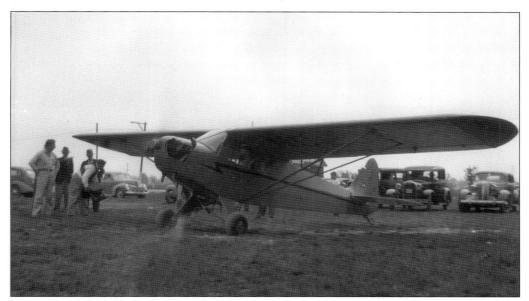

PIPER CUB AIRPLANE. Aviation in the Clarksville area dates to the 1920s when Russell Beeler established a flying field on what is now Clark Boulevard in the area of Midway Park. The operation was relocated around 1930 to a site on Eastern Boulevard where Value City now stands. Beeler is the man bending over; the others are unidentified.

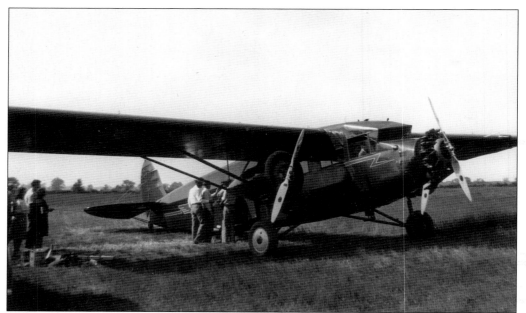

STINSON TRI-MOTOR AIRPLANE. The airport was operated as a private airfield and had two small hangars. During the late 1940s, the Beeler airfield was taken over by Robert Bush of Ramsey, Indiana. Eventually, land values dictated that his airport give way to residential and commercial development, and it closed about 1950.

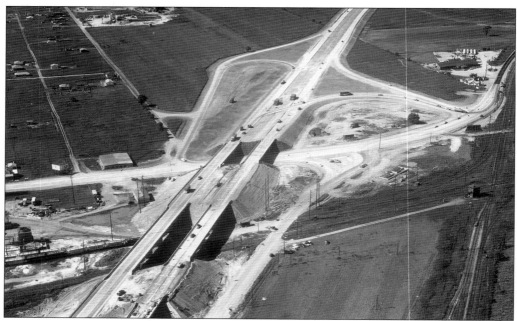

INTERSTATE 65 UNDER CONSTRUCTION. The interchange of I-65 and Highway 131 is shown during construction of the interstate through Clarksville. The old Log Cabin, a popular nightclub of the 1930s, can be seen at upper right. At the time shown the Silgas Company occupied the site.

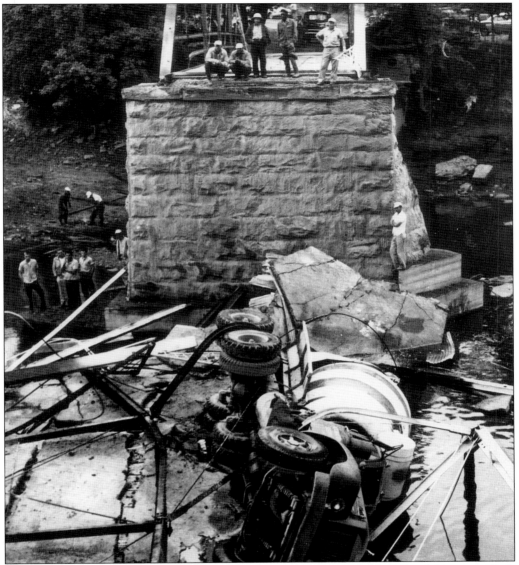

BLACKISTON MILL BRIDGE COLLAPSE. The bridge, which spanned Silver Creek between Clark and Floyd Counties, collapsed under a cement mixer on May 15, 1963. It was undergoing repair at the time. The four men in the concrete truck were injured, but survived. Originally built in 1888, the iron bridge stood next to Blackiston's Mill, which was built in the 1850s by the Very family. A dam a few feet upstream of the bridge was called "Fourth Dam," since it was the fourth dam on Silver Creek from its mouth.

The road from Clarksville to New Albany had originally crossed a few hundred yards downstream from Blackiston's Mill, at an earlier mill at "Third Dam." That was the site of an early ford of Silver Creek, since there was never a bridge there. There were a number of drownings at the Third Dam ford. One story was of a German family, crossing in a wagon, whose child was lost. When Very built his mill he persuaded Clark County officials to build the road past his mill, and that is the route used today. (Photo courtesy of the *Louisville Courier-Journal.*)

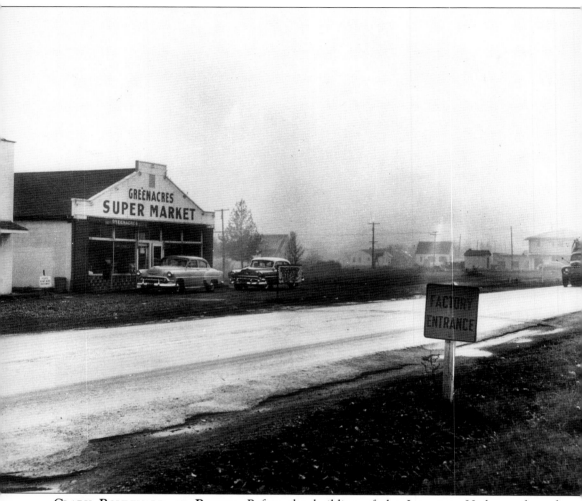

CLARK BOULEVARD AT BOWNE. Before the building of the Interstate Highway through Clarksville, Clark Boulevard was the main road between New Albany and Jeffersonville. Originally two lanes, a four-lane highway replaced much of this section of the street. The name has been changed to Brown's Station, which was the name of an Interurban train stop in the early part of the century. This photo is probably about 1954. The neighborhood of Greenacres, developed in the 1940s, is to the left. The building that housed the Greenacres Super Market still stands, but with a solid wall in the front where windows once were. (Photo courtesy of the *Louisville Courier-Journal*.)

Six

HAVING FUN

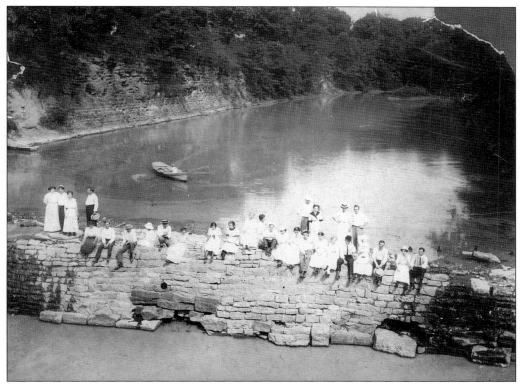

RELAXING ON BLACKISTON'S MILL DAM. This group is shown at the dam on Silver Creek about 1910. The mill, which is on the Floyd County side of the creek, and the dam were built in 1853 on land that brothers Martin and Lawson Very had purchased from members of the Illinois Regiment. It was originally a saw and cement mill. B.F. Blackiston inherited the mill in 1871, but progress soon caused the old mills to fail, so Blackiston turned the mill into a dance hall and the Clarksville side of the creek into a park about 1892. In 1895 the park was sold out of the family. There was a succession of owners, but the park continued to be a popular swimming, fishing and picnicking area until the 1970s.

Silver Creek had several mills and at least one boat-building operation along its banks. Much of the creek remains in its original state today, since very steep-sided banks limit access.

A River Swim. Residents who lived close to the Ohio River often swam and waded there, since there were few other places for swimming at the turn of the century. The lady third from the left appears to be in bathing costume. This unidentified group is below the Pennsylvania Bridge before 1915. This location would become the site of Dam 41, 20 years later.

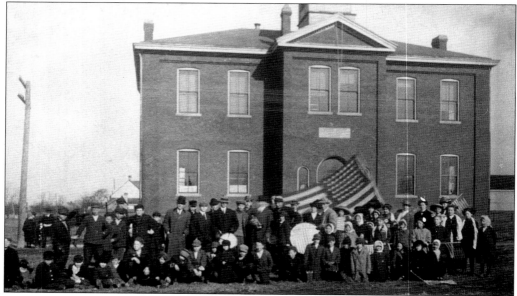

Thanksgiving Day, 1911. This unknown group got together at George Rogers Clark School to raise the flag on Thanksgiving Day. Two men are holding a bass drum and the gentleman in the top hat is holding a trumpet, so it would appear there was also a musical program. From the clothing worn, it was a chilly Thanksgiving Day.

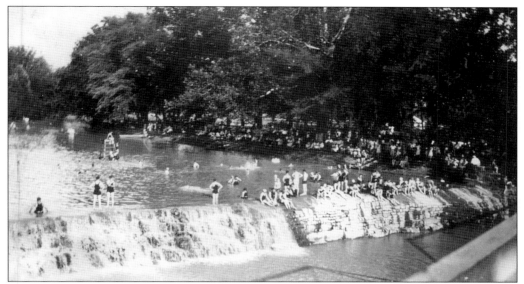

BLACKISTON'S MILL PARK. The popularity of the park is shown by the large crowd of swimmers and picnickers in this photo taken in the 1930s. The view is from the iron bridge, which crossed the creek by the dam until it fell in 1963. The mill is gone but the dam remains today. The old park is no longer used by the public.

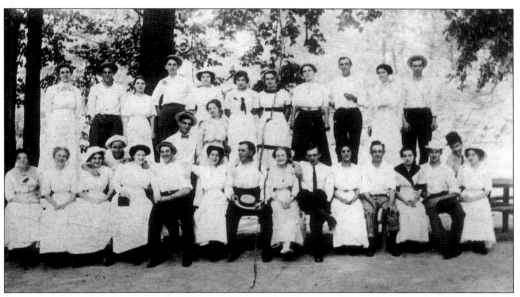

PICNIC, 1910. Blackiston Mill Park was the grand gathering place of many school and church events for more than one hundred years. Pictured, from left to right, are as follows: (front row) Maud Howell, Grace Shannon, Mary Ike, Fred Wells, Iva Stewart, Lewis Detrick, Josie Burns, Charles Leap, Susie More, Jack Bloom, Mrs. Mattie Welker, Mr. Howard Welker, Maud Landware, Early Chandler, Lafe Grover, and Grace Sands; (back row) Annabel Shannon, Roy Hollowell, Anna Shage?, Charles White, Gene Smith, Margie Chandler, Cecil Landware, (?) Shannon, Ray Hambough, (?) Grover, and George Fleenor. Claude F. Hollowell and Lucille Burns are standing between the rows.

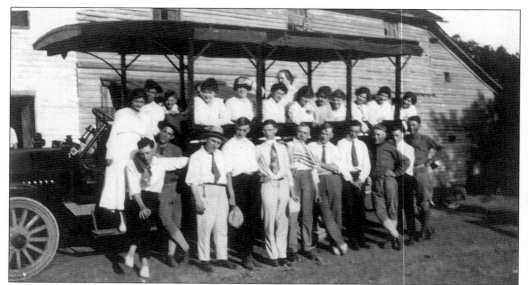

A Day at Blackiston's Mill Park. This large group is shown in front of Blackiston's Mill about 1915. The owner of the open-sided bus is unknown. It may have been operated by the park, or borrowed from a local business. The members of the group are unidentified.

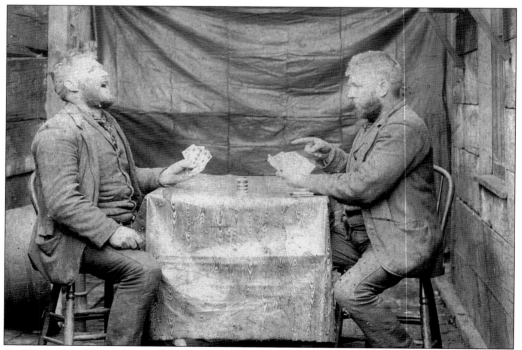

An Unusual Card Game. In the trick photo, Pete Bunnell is seen playing cards with himself. Pete and his wife Mary had moved from Jeffersonville to Lee Street (now State Street) in the Ohio Falls neighborhood of Clarksville about 1880. Pete was a carpenter and enlarged their four-room home to accommodate their growing family of Elmer, Bertha, Gert, Thelma, Arvin, and Maude.

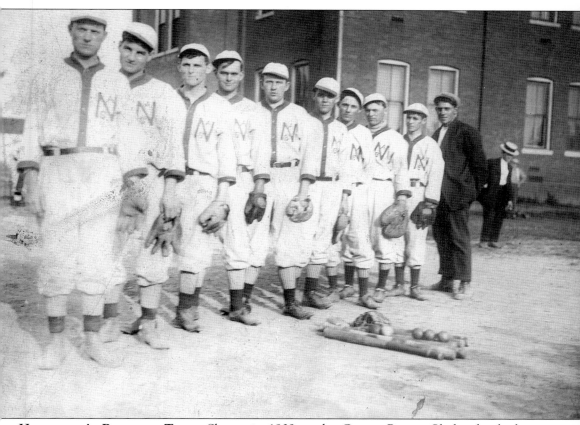

HOLLOWELL'S BASEBALL TEAM. Shown in 1909 at the George Rogers Clark school, the team was sponsored by Hollowell's Grocery, which was at the corner of Clark Boulevard and Stansifer Avenue. Players, from left to right, are as follows: Fred Mayfield, Claude Hollowell, Roy Hollowell, Edward Long, George Cole, Edward Hollowell, Emmett Bodkins, Lawrence Mayfield, Walter Stites, and James Snyder.

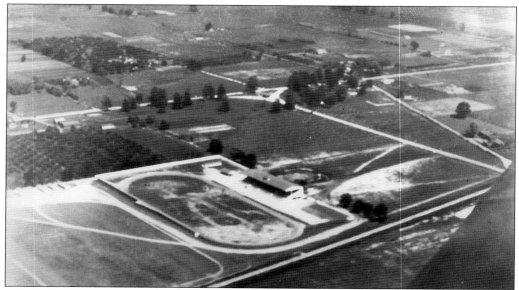

THE GREYHOUND DOG TRACK. In 1929 Joe H. Adams, a dog racing promoter, opened the greyhound track. It was called the Jeffersonville Dog Mart, although it was in Clarksville, and was at the site of the present-day Beechwood Manor subdivision. To get around the gambling laws, patrons purchased "shares" in certain dogs. If the dog won, the patron sold the "shares" back to the management. The track seated 3,000 people and closed in 1936.

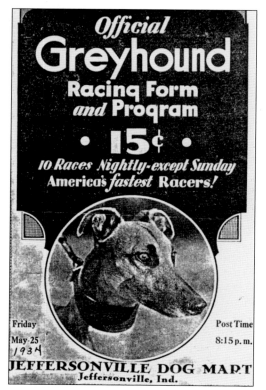

GREYHOUND PROGRAM. This program and racing form was from May of 1934, at the height of the track's popularity. The track's last year of operation was 1936. The Brumett family trained dogs for the races.

THE CLUB GREYHOUND. Widespread gambling once flourished in Clarksville and nearby Jeffersonville. The original Club Greyhound was built across from the dog racing track and stood about where the Triangle Shopping Center is today. It burned in 1934 and the building shown above was erected on Highway 31 near Hallmark Drive. The nationally known club featured craps, blackjack, roulette, and horse race betting. There was an elegant dining room. The menu included Russian Caviar ($1.00), Broiled Tenderloin Steak with french fries and sliced tomatoes ($1.75), and Jumbo Frog Legs ($1.50).

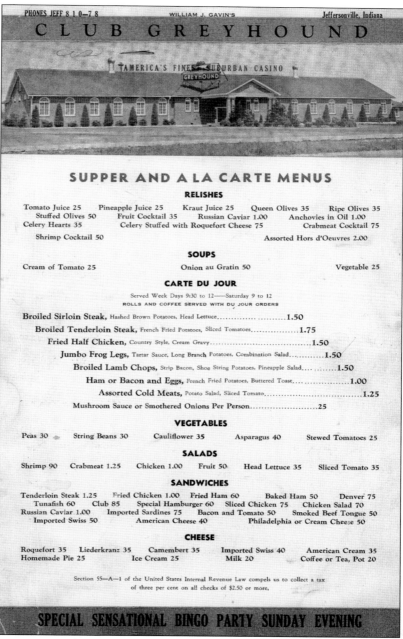

The club offered entertainment by nationally prominent artists such as Al Jolson and Helen Morgan and dance music was by Glenn Miller, Tommy Dorsey, or other famous bands of the day. Free transportation to and from Louisville was provided by the nightclub.

The nightclub closed in 1939 but was rented for private parties until about 1951. In 1953 it became a grocery store, also named the Greyhound. The original building was demolished in 1980. Remnants of the original decorative wall that surrounded the nightclub still can be seen bordering the parking lot.

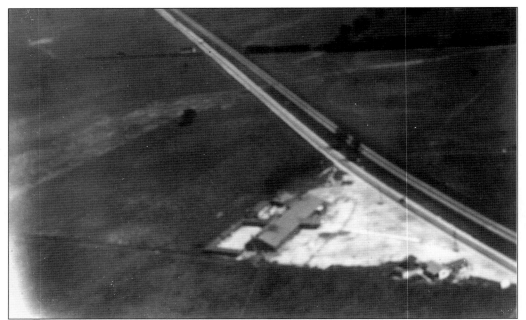

THE LOG CABIN. Located at old Highway 31 and Highway 131, this nightclub was built in 1927 by Claude Williams. It had a main building and 50 small cabins. Lawrence Welk, Tommy Dorsey, and Glenn Miller were some of the big bands that played there. The attraction, as with so many of Clarksville nightspots, was gambling. The Log Cabin burned in 1929 but was rebuilt within the following year.

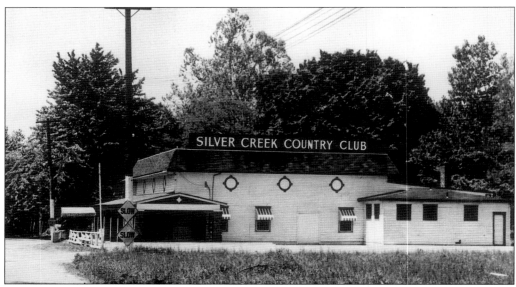

THE SILVER CREEK COUNTRY CLUB. Located on the banks of Silver Creek at old McCulloch Pike, this club's owner was reputed to be associated with Al Capone and his Chicago gang. When the club opened in 1933, one of the patrons was Capone's personal bodyguard. In 1938 and 1939 there was a concerted effort to crack down on the area's illegal gambling and this and most of the other clubs were closed permanently. (Photo courtesy of the *Louisville Courier-Journal*.)

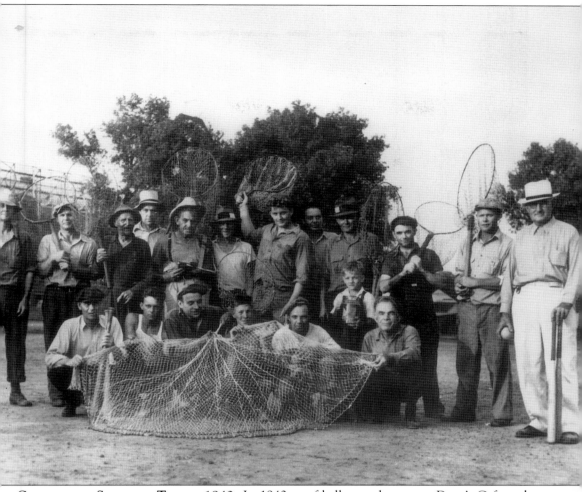

CLARKSVILLE SOFTBALL TEAMS, 1940. In 1940 a softball team known as Dean's Cafe and the team pictured, known as The Fishermen, would get together one day each week to play softball. Rules of the game were, when the batter hit the ball, the team in the field had to catch the ball in his dip net and then try to make a play at the bases. No gloves were used, and both teams used the fishermen nets. Charles Dean, owner of Dean's Cafe, furnished a half-barrel of draught beer, which was tapped and set on the base line. Players drank during the game and the spectators were also welcome to drink the beer.

The score of the game was usually high since the player had to retrieve the ball from the net before a play could be made at the bases. If the ball was hit in the air it was almost a sure out.

Team members, from left to right, are as follows: (front row) Mr. Clark, Mr. Deweese, Coen Lysle, Marvin Burns, George Rogers, Lefty Haworth, and George Rogers Sr.; (back row) Gene Grey, Gabe Bethel, John Stites, Louis Knowland, James Snyder, Fred Kaelin, Jim Robinson, Millard Riggle, Bob Long, George Kopp, Charles Long, and Bill Fuller.

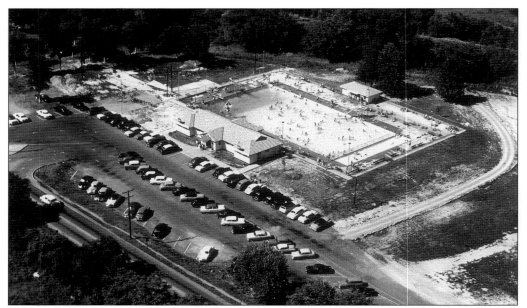

THE CLARKSVILLE MUNICIPAL POOL. One of the first municipal pools in the area, the pool was the scene of many pleasant times for Clarksville citizens. It was built after two boys drowned while swimming in the river. It opened in 1951 and operated until the end of the 1993 season. A new aquatic and tennis center opened on the site in July of 1995.

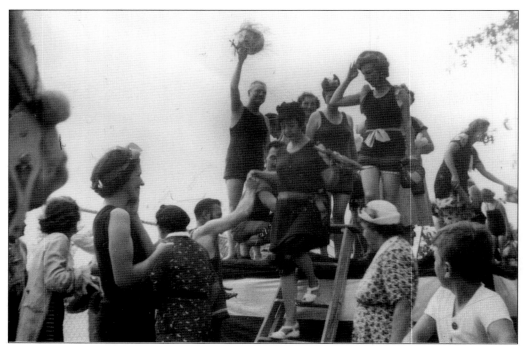

MUNICIPAL POOL OPENING PARTY. The opening of the new municipal pool was the occasion of a large party and parade. This photo features the "Bathing Beauty Contest" in which local ladies dressed in bathing suits of an earlier time.

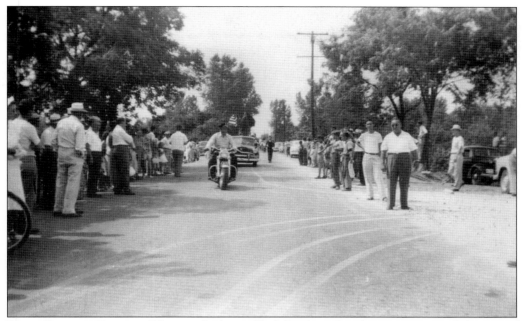

POOL OPENING PARADE. The parade down Clark Boulevard is shown as it passed the site of the pool. Town Marshall Woodrow is shown leading the parade on a motorcycle. Spectators are unidentified.

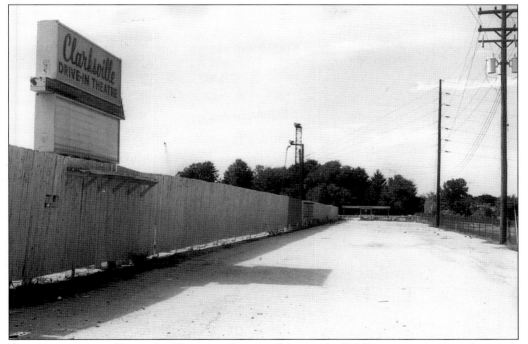

THE CLARKSVILLE DRIVE-IN THEATER. It opened in April of 1950, was situated on the south side of State Road 562 (now Brown's Station Way), and accommodated 600 cars. The theater operated from April to early November. It closed permanently at the end of the 1984 season.

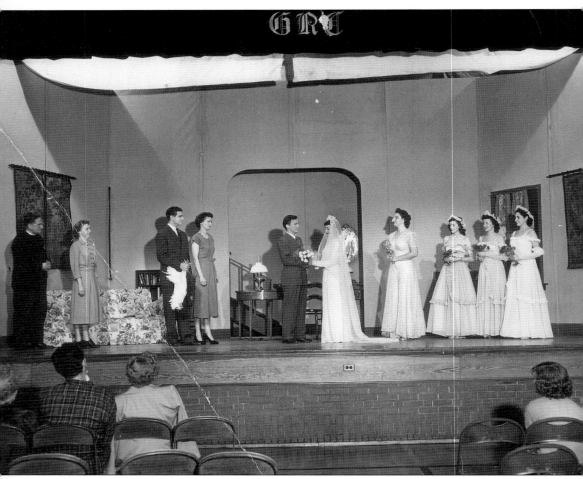

CLARKSVILLE LITTLE THEATER. The theater is one of the oldest community theater groups in the country, performing its first production in 1947. In the early day plays were held at the George Roger Clark School and at the Optimist Club building on Clark Boulevard. The group built their own theater building in 1953, where productions are still being staged. In the picture above, the first seven people from the left are unknown. Beginning with the eighth from the left, from left to right, are Dorothy Dickey, Libby Chapman, and Maxine Howerton.

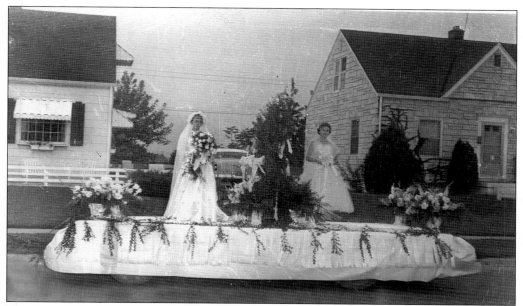

FESTIVITIES IN GREENACRES. This parade, for an unknown occasion, is shown on a street in Greenacres. This area of Clarksville was developed in the 1940s and brought an influx of new citizens to town, causing those neighborhoods that had been established in the nineteenth century to be known as "Old Clarksville." The date appears to be in the early 1950s. The ladies on the float are unidentified.

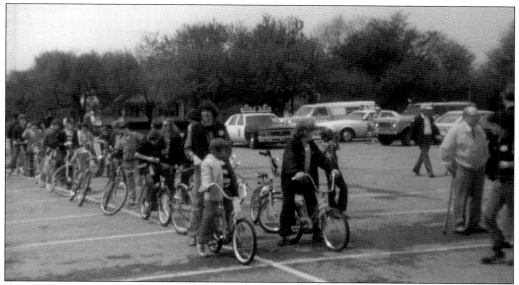

CLARKSVILLE OPTIMIST CLUB. Pictured is a club-sponsored 20-mile cyclethon in 1981. Cyclists rode from Green Tree Mall to Wathen Park in Jeffersonville and had a picnic at the park. A newspaper of the '30s and '40s, The *Clarksville Tribune*, was largely an Optimist effort. The club built a Boy's Club, which in the 1950s and '60s, was popular with the town's young people. The group currently sponsors numerous children's programs in conjunction with the Clarksville Parks Department.

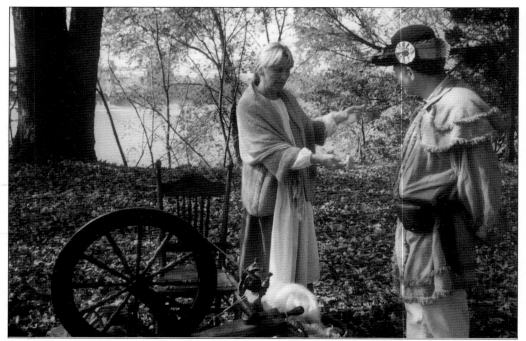

CLARKSVILLE IN 1803. Each October, Clarksville hosts a reenactment of the town in 1803 to commemorate the departure of Meriwether Lewis and William Clark with their Corps of Discovery. Artisans demonstrate skills and arts of the period, militia and the Illinois Regiment march and drill, and period food is served. Shown here is a weaver at her work in a spot overlooking the Ohio River.

HIKING SILVER CREEK. The Clarksville History Society is shown on a field trip in historic Silver Creek. In pioneer times, this creek was the dividing line between the small settlement of Clarksville and the Indian lands. A man named Springer was caught after hunting on the other side. He ran for the creek but was caught and killed at a place afterwards known as "Springer's Gut."

Six

THE RIVER

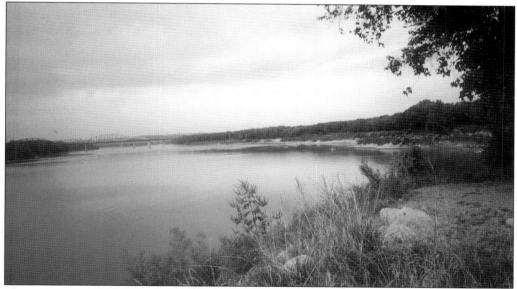

THE RIVERSIDE SITE OF THE ORIGINAL TOWN. This view is from just below the hill where General George Rogers Clark built his home. The sandy banks on the right identify the site of the 18th-century town of Clarksville. The small bay on the right is the mouth of Mill Creek, where the Lewis and Clark expedition pushed away on their westward journey on October 26, 1803.

The town's location on the banks of the Ohio River was both a boon and a curse. Its power provided the main highway of the day and ran the many mills that provided flour, and later cement. But its waters periodically overran its banks and created devastation. Major floods took place in 1832, 1847, 1907, and 1913. Nineteen thirty-seven brought a "hundred year flood"—the worst in living memory. It resulted in the building of floodwalls that, since the 1940s, have protected the surrounding cities. The site today is surrounded on all sides by a large metropolitan area, but its isolation allows it to retain its natural and scenic character. The bridge in the distance is the K&I bridge between New Albany, Indiana, and Louisville, Kentucky.

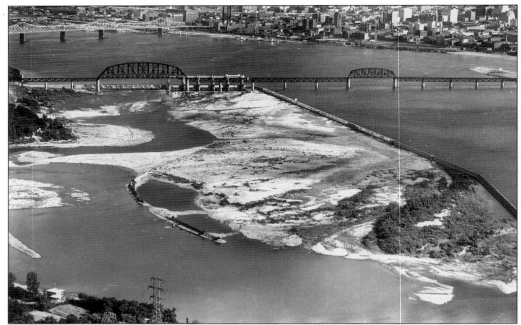

THE OHIO RIVER AT CLARKSVILLE. The McAlpine Dam can be seen under the left side of the Pennsylvania (now the Kentucky-Indiana) Bridge. In the middle of the river, the dam turns downstream and follows that direction until the end of the locks, which are located out of view on the right. Fossil beds are exposed in the center of the photo.

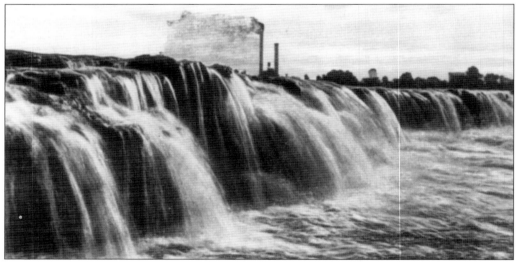

THE FALLS OF THE OHIO. Actually a great fossil reef, which extends across and for some distance on the Ohio between Clarksville and Louisville, Kentucky, the largest of the drops is shown here. The river had a total drop of 26-feet in a distance of three and two-tenths miles. The only barrier to navigation in the 981-foot length of the Ohio River, the Falls made the site a logical place for settlement and commerce, as many boats had to wait for high water to get past the obstruction. Since the construction of the dam and lock system, drops such as this one are seldom visible.

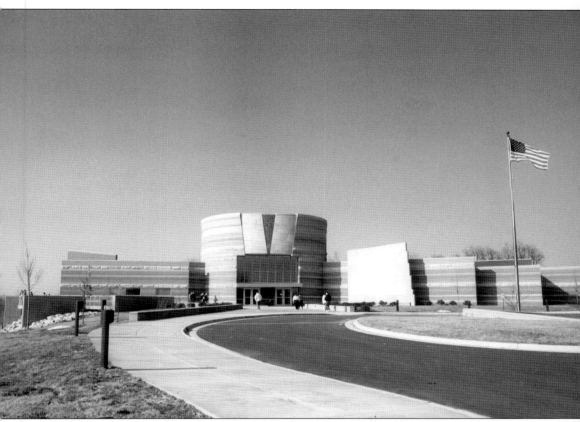

FALLS OF THE OHIO STATE PARK. The 68-acre park lies along the north shore of the Ohio River in Clarksville. The site was designated a Wildlife Conservation Area in 1982 to protect the fossils and habitat at the Falls and became a state park in 1990. Shown is the Interpretive Center, which opened in January of 1994, and contains history and geology exhibits as well as providing naturalist service and educational programs.

HORN CORALS. These horn corals are some of the innumerable fossils found at the Falls of the Ohio River. The fossil beds belong to the Devonian age and date to a time when a shallow inland sea covered the area, 387 million years ago. As the corals and other sea inhabitants died, they were buried in layers of sediment and eventually became fossilized. Erosion of the land after the Ice Ages exposed the ancient sea floor.

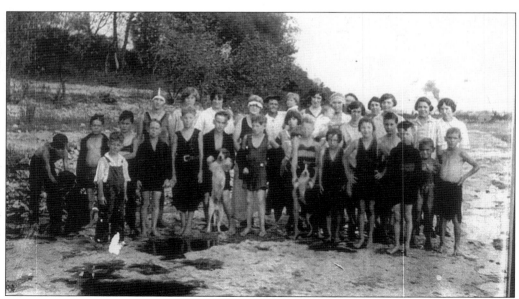

AT THE FALLS IN 1924. For many years, individuals and groups have visited the fossil beds at the Falls to marvel at the many remnants of a prehistoric age. This group is shown in an area formerly known as Vinegar Hill, now Riverside Drive. Today the Falls State Park gets around 500,000 visitors yearly.

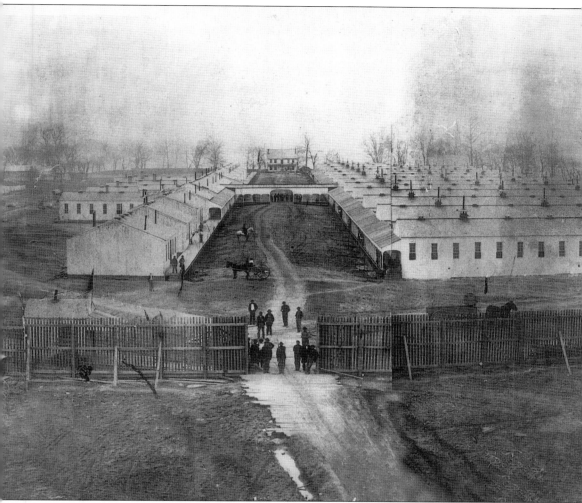

Camp Joe Holt. In July 1861, Colonel Lovell Rousseau of Louisville opened a recruiting camp on the Clarksville riverfront at Little Eddy, the present site of the Falls of the Ohio Interpretative Center. Within two months, there were two-thousand men of the Fifth Kentucky Infantry (known as the "Louisville Legion"), quartered at the camp. One company, headed by Captain Edward J. Mitchell, was the only company at that time in which men from Clark County were enlisted. On the second day at the camp, a Captain Trainor nailed to a tree at the camp's entrance, a pine board on which was written "Camp Joe Holt," and thus it became the namesake of Joseph Holt, Secretary of War for the Federal Government.

After the Louisville Legion marched south, the camp became the staging area for other Union troops. Eventually the camp became Joe Holt Hospital and served in that capacity until 1864, when the Jeffersonville General Hospital was built. The site was used almost continuously for troops coming and leaving until nearly the close of the war. (Photo courtesy of the *Louisville Courier-Journal*.)

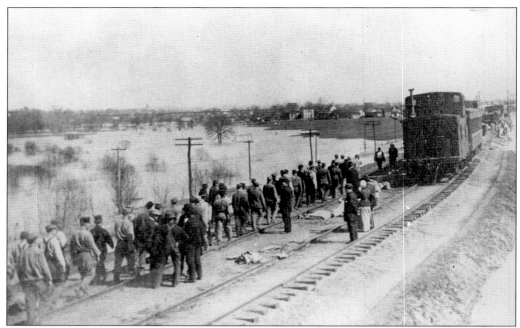

SAVING THE INTERURBAN TRACKS. Prisoners from the Indiana Reformatory were called in to sandbag the Interurban tracks when they were in danger of being destroyed by the 1913 floodwaters in April of that year. The flooded area known as "Lick Skillet" can be seen in the background. Remnants of some of the sandbags can still be found there today.

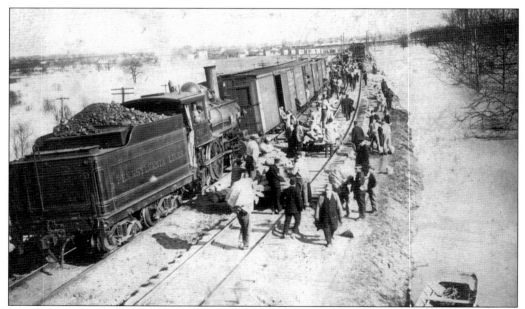

THE 1913 FLOOD. The prisoners are shown unloading sandbags on the section of Pennsylvania Railroad track that went to Louisville. Their efforts were successful. Prison guards are keeping watch over the group. Floodwaters are on either side of the track, which is just north of the Indiana Reformatory. A Clarksville park and aquatic center occupies the area today.

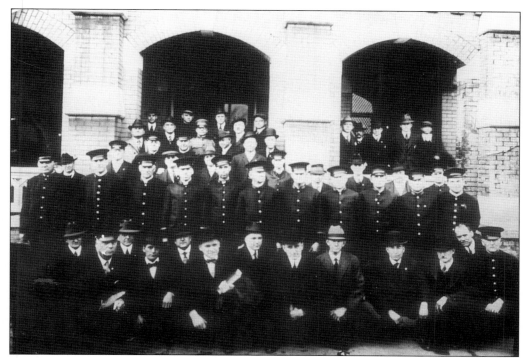

A Delegation to the Prison. Leading businessmen and dignitaries made a trip to the Reformatory to personally thank the prisoners who filled sandbags and constructed a levee during the 1913 flood. Superintendent Peyton welcomed the citizen's committee, which then served a dinner at the institution to all the prisoners. The scene is the front gate of the Reformatory. The men are not identified.

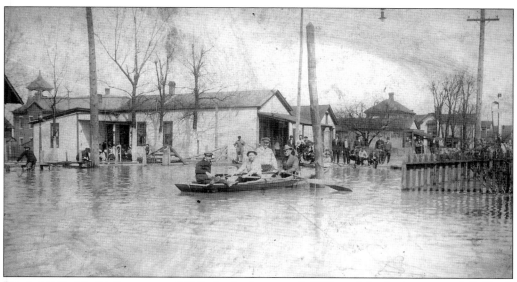

Boat on Beckett Street in 1913. In the boat are S. Wilson, Myrtle Aigner, and C. Ettel. The water covers the Dinky tracks underneath the boat. Residents spent many months after the flood cleaning mud out of homes.

OCTAGON HOUSE. Built along Clarksville's riverfront, the Octagon House was a well-known landmark of Clarksville. It was said to be one of only five houses of that shape in the country. Its builder, Sidney S. Lyon, was a noted geologist and served the Union Army in the rank of Major during the Civil War. He surveyed the Cumberland Gap for the Army, and was severely wounded in the battle there. After the war, he became surveyor for Clark County. His son Victor also served as county surveyor in later years.

Major Lyon first built the Octagon House in 1852 out of an experimental sand and gravel mixture, but soon after completion, it was entirely destroyed by a heavy rainstorm. He rebuilt it in 1853 and the Lyon family lived there until 1890. The last resident was Clarksville councilman Alvin Bunnell who lived there until 1940, when it was demolished to make way for the levee. The Smith-Smyser Mill, built in November of 1853, was on the riverbank just across the street from the Octagon House.

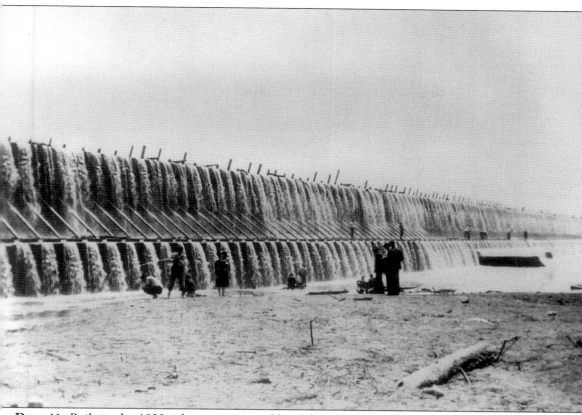

DAM 41. Built in the 1920s, this was a moveable wicket dam. The wickets were constructed of large oak timbers, and, in the raised position, controlled the pool elevation above the dam. The wickets were raised or lowered by a crew working from a "maneuverboat." McAlpine Dam, built in the early 1960s, replaced Dam 41. It was named for William H. McAlpine, who served as district engineer during World War I.

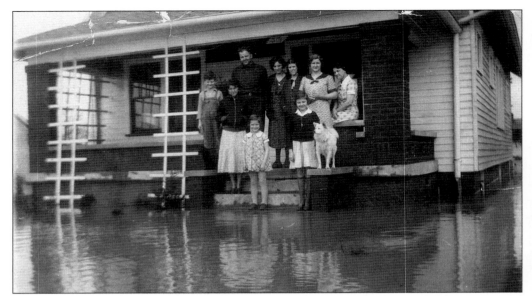

A One-Hundred Year Flood. In 1937, the worst flood in local recorded history caused almost the entire population to suffer. The family of Bill and Margaret Abel stands on their front porch on Stansifer Avenue. Very few houses in Clarksville were left untouched by the floodwaters. Flood victims were evacuated to Indianapolis and other points north by train.

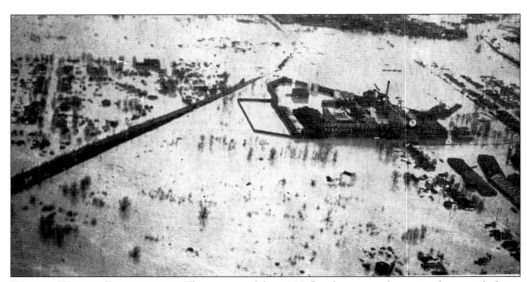

Water, Water, Everywhere. The extent of the 1937 floodwaters is shown in this aerial photo of the area surrounding the Colgate plant (the old prison facility). Floodwaters were 8-feet high on the sidewalk in front of the plant. The company had replaced the metal rack floor of the former cellblock "B" with a concrete floor for company offices. Flood victims were taken into that building for shelter, and filled the building. Production was halted at the plant for more than a month.

FIREHOUSE IN 1937. Bill Abel stands in floodwaters in front of the first Clarksville Fire Station on Stansifer Avenue in Jeffersonville. Rainfall began on January 9 and continued until January 15. It resumed again on the 17th and fell until January 23.

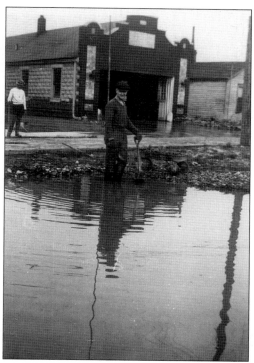

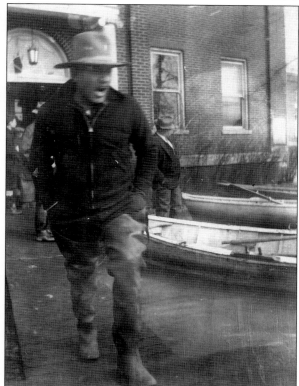

FLOOD RESCUE. Charlie Seitz, a local fisherman, is shown in front of George Rogers Clark School. Wearing hip boots, he was one of a number of river-men who ferried people to the school for refuge during the flood. One story is of a woman who would not leave her home without her cow. The men used two boats tied together, put the cow's front legs in one, the back legs in another, and evacuated the cow.

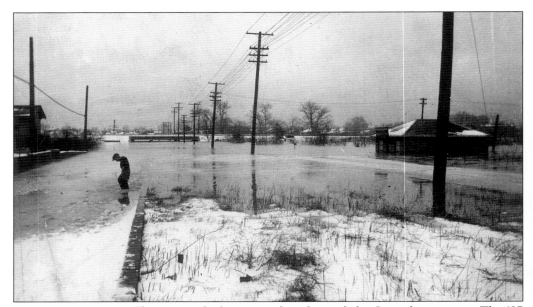

STANSIFER AVENUE. The view is looking west from beyond the Stansifer overpass. The '37 flood was described as "an inundation of almost biblical proportions." It crested at nearly 10-feet above the previous record level. The flood lasted for 23 days during the coldest part of the winter. The rain sometimes fell as sleet or freezing rain.

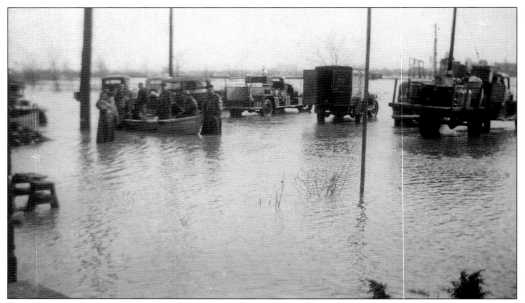

STANSIFER AVENUE IN THE '37 FLOOD. These men are probably bringing relief supplies and evacuating residents. Many residents were taken to Indianapolis by train, to stay in private homes or hastily arranged shelters. On February 6, the river finally dropped below flood level.

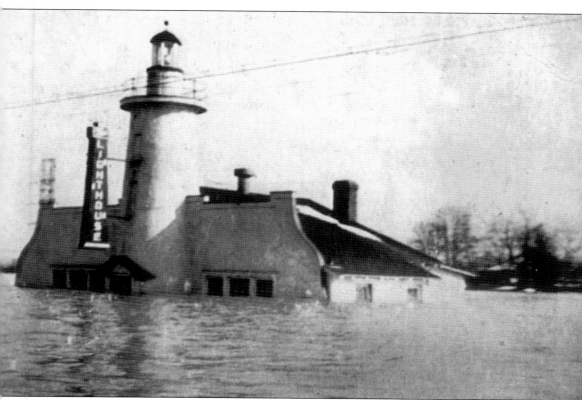

THE LIGHTHOUSE IN 1937. The Lighthouse was a restaurant at 808 West Highway 131, across from present-day Providence High School. Although more than a mile from the Ohio River, it was close enough to feel the effects of this disastrous flood—one of the worst in American history. The Ohio River crested at almost 58 feet, which surpassed the previous record level of the 1884 flood. The building is still standing today, although the top part of the "lighthouse" has been removed.

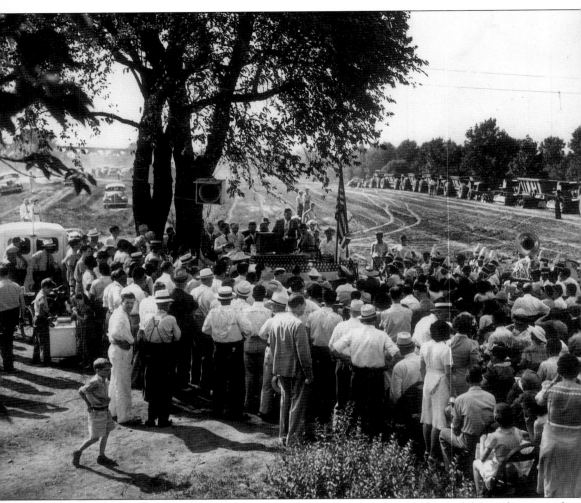

THE FLOODWALL ARRIVES. On July 22, 1940, ceremonies were held to celebrate the start of construction of the new floodwall and levee which was about to be built by the U.S. Army Corps of Engineers. Earl Seabrook, president of the Jeffersonville Board of Trade is shown speaking to the crowd. The Pennsylvania Bridge can be seen in the distance, upper left. The levee cost the town some of its historic landmarks, such as the Cobblestone Pike and the Octagon House, but floodwaters have not caused a major problem since its construction. (Photo courtesy of the *Louisville Courier-Journal*.)

Eight

THE PRISON

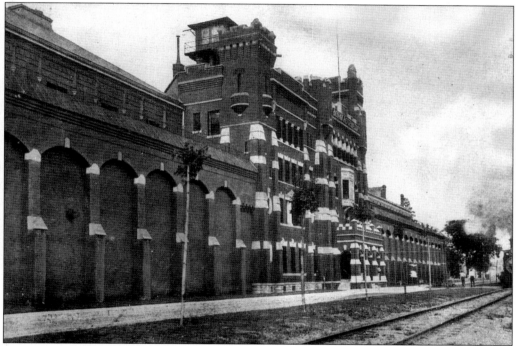

THE INDIANA REFORMATORY IN 1906. The first Indiana state prison was moved to Clarksville from Jeffersonville in October of 1847. There were 150 convicts that year, and the prison consisted of one cell house with a board wall around it. Abuses were common. Excessive brutality was the rule. Inmates were not allowed to keep personal items such as pictures of their wives, and letter writing was restricted to one letter per month.

In 1861 a second prison, Indiana Prison North, was built and the Clarksville facility became Indiana Prison South. Conditions grew so bad that a special investigation was called by the governor, which resulted in a new warden being appointed. Colonel Shuler of Danville, Indiana, proved to be a humane and progressive warden, initiating many reforms.

The latter part of the 19th century saw a dedicated prison reform movement, and in 1897 Indiana Prison South became the Indiana Reformatory. In 1918 a large fire destroyed a large part of the prison. The complex never really recovered, and in 1923 was sold to the Colgate Company. (Photo courtesy of the *Louisville Courier-Journal*.)

CELL HOUSE "C." Constructed in 1901, it was the largest of the cell houses and held 600 prisoners. It was 60-cells long and 5-cells high. Each cell was about 6-feet wide by 10-feet deep. Each had running water, a toilet and washstand, electric light, wire spring bed, shelf, and chair. In October of 1901, there were 895 inmates in the prison.

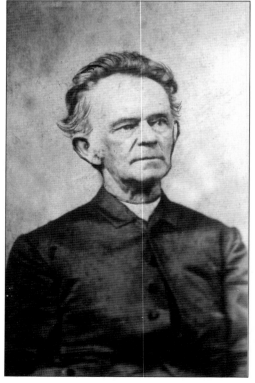

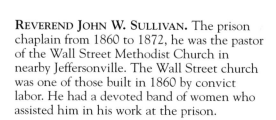

REVEREND JOHN W. SULLIVAN. The prison chaplain from 1860 to 1872, he was the pastor of the Wall Street Methodist Church in nearby Jeffersonville. The Wall Street church was one of those built in 1860 by convict labor. He had a devoted band of women who assisted him in his work at the prison.

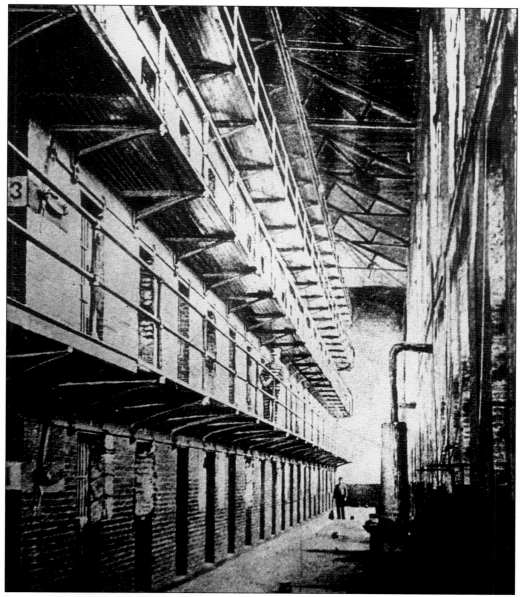

PRISON CELL BLOCK, C. 1890. Inmates were not allowed to use tobacco or possess any reading materials, except for an occasional religious tract provided by the chaplain. At the turn of the century there were 877 prisoners. Prisoners were beaten, tortured, and flogged with a cat-o-nine-tails. Cell House "B" was built about 1847. It originally contained 184 cells and was three tiers high.

In its early days, the prison received women prisoners as well as men. The first women prisoners had been convicted of helping slaves escape to Ohio in 1845. After the administration changed in 1865, the institution began a reign of riot, lust, and brutality that continued for several years. A state investigation of conditions led to the Indiana Reformatory for Women and Girls being founded in 1869. The new women's prison was completed on October 4, 1873, and the Clarksville prison no longer received women.

THE PRISON CEMETERY. The number of inmates who died from hanging, brutality, illness, or shot while trying to escape is unknown. In 1850 there were 148 deaths at the prison, 35 of them from cholera. There were at least two smallpox epidemics at the prison. In 1888 a man named Macey Warner was hung at the prison for having killed a fellow inmate. A crowd gathered to see the hanging and received pieces of rope for souvenirs.

THE PRISON POTTER'S FIELD

(Author Unknown)

Across the way still lies the ground

Where their forgotten graves were found.

The Potter's Field for one and all

Who, friendless, died within the wall.

A kindly warden planted there

Old-fashioned flowers to make it fair:

Covered the cold, unhallowed soil

With beauty's touch and reverent toil;

Making a garden round about

Where green things grew and those who doubt

The Eden of man's long-lost good

May still have faith, as wise men should.

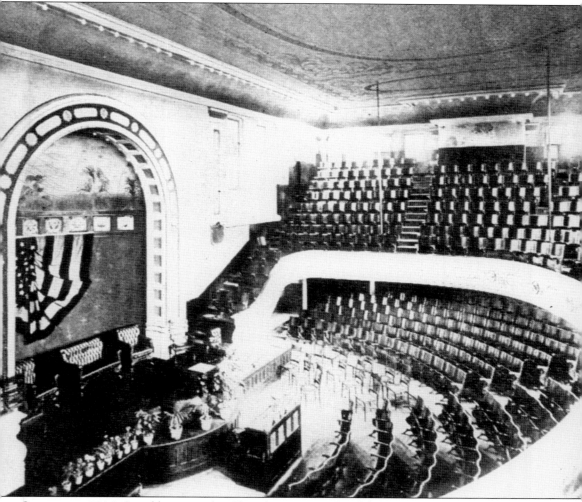

CHAPEL IN 1916. In addition to the Chapel service on Sunday morning, there were special classes for instruction in religion and a Sunday school where the "International Sunday School Lesson" was taught. A "Federated Church" was organized which accepted men whose records were clear for a "reasonable period of time." They could designate the denomination they wished to affiliate with and were given a letter of dismissal to any church when they left the prison.

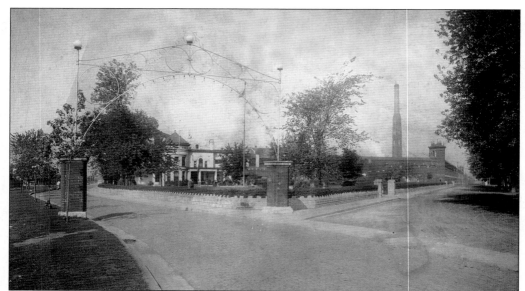

THE ENTRANCE TO THE PRISON GROUNDS. The view is looking west from Missouri Avenue. The superintendent's residence can be seen through the ornamental gate over the brick street that is now Clark Boulevard. The grounds of the residence included a greenhouse and beautiful flower gardens. The site of the residence is now a parking lot of the Colgate Company.

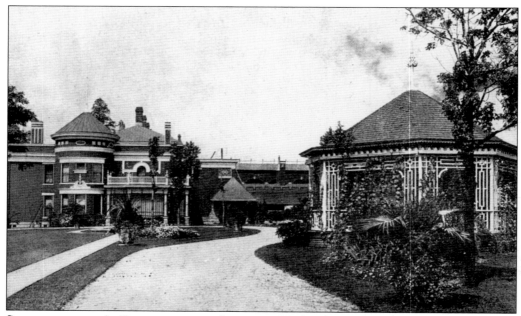

SUPERINTENDENT'S RESIDENCE AND GARDENS. Under the original system, the prison was leased to private individuals who fed, clothed, and maintained the prisoners from money made by farming them out to the highest bidder. The profits after the maintenance costs and the lease payment belonged to the lessee. In 1846, S.H. Patterson contracted the entire prison work for $10,000 per year. The lease system was changed to one of an elected warden in June 1848. William Lee was the first warden and served until 1849.

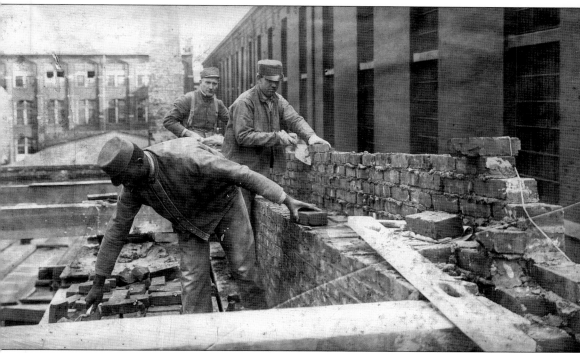

MASONRY TRADE SCHOOL. In earlier days at the prison, inmates were often taken outside the prison to work in the community for the highest bidder. The bricks in many of the homes in the area were made by prisoners. In 1860, the local citizens became aroused at the competition, which made it hard for local craftsmen to find work, since the prisoner's work was much cheaper. The prison warden had contracted to furnish brick for the Louisville Water Works, which was then being built. One day, while the convicts were being marched through the city streets to the brick works in the Claysburg area, a mob of citizens formed to protest the practice of unfair competition. They became unruly and the prisoners, who were chained together, were driven back to the prison. That incident halted all work outside the prison.

The masonry school curriculum included stone cutting, bricklaying, concrete making, and monument lettering and carving. Among many other constructions within the prison walls, the inmates built a hospital. Much of their handiwork endures today.

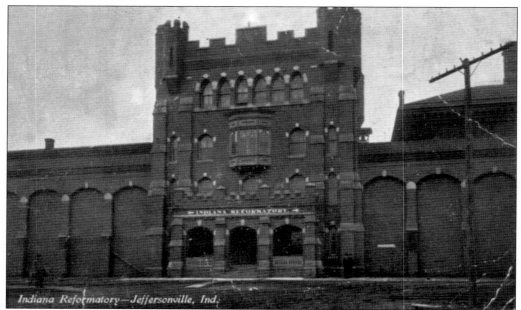

Indiana Reformatory—Jeffersonville, Ind.

PRISON MAIN GATE. Captain J.B. Patten became superintendent in March of 1887. When he arrived, he found the prison in a deplorable condition. It had three brick walls, one on the south, north, and east, while the western enclosure was nothing but a high board fence. Convicts attempted escapes from there and it was not out of the ordinary for one to be shot down by a guard. Patten designed a new brick wall and supervised its construction during the summer of 1897. At this time, the imposing entrance was added.

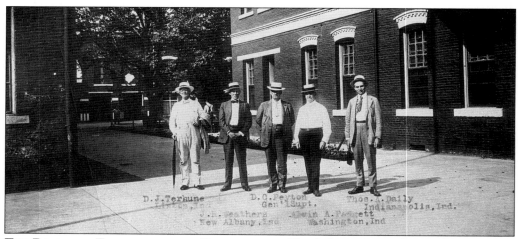

THE BOARD OF TRUSTEES OF THE REFORMATORY. The Indiana General Assembly approved an act making Indiana State Prison South the Indiana Reformatory on February 26, 1897. It provided that prisoners convicted of certain crimes, such as treason or murder in the first or second degree, or persons over 30 years old be sent to the Indiana State Prison North in Michigan City. Named as trustees of the new Reformatory, from left to right, are: D.C. Terhune of Linton, John Weathers of New Albany, Alvin Padgett of Washington (Indiana), and Thomas Daily of Indianapolis. Standing in the center is David C. Peyton, who was the superintendent of the Reformatory.

BOARDROOM OF THE REFORMATORY. With the change in status, the philosophy changed from one of punishment to a real effort to rehabilitate the prisoners. On Christmas Day of 1897 the first issue of a weekly newspaper, *The Reflector*, was issued. A group called the Brighter Day League visited the Reformatory regularly and staged entertainment for the prisoners. Prisoners were taught trades, and baseball games were organized.

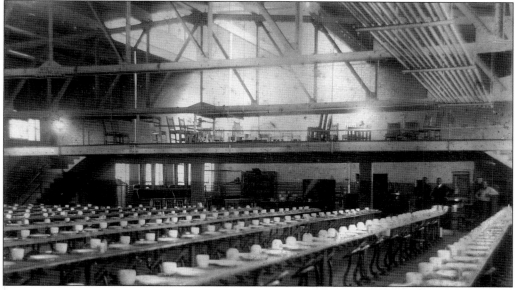

THE DINING ROOM. The capacity of the room was 1,050 men. At a given signal from the presiding officer, the meal was begun and eaten in silence. The men were not served a certain ration, but allowed as much as they wished. Breakfast was at 7:00 a.m., dinner at noon, and supper at 4:30 p.m. The only meal not eaten in the dining room was supper on Sunday, which was eaten in the cells.

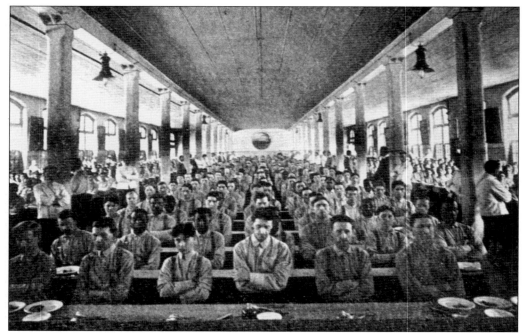

PRISONERS AT DINNER. At the evening meal, the men sat in silence with their arms folded while the "Star Spangled Banner" was played. A 1910 menu gives breakfast as boiled rice with raisins and sugar, bread and butter, and coffee. Lunch was roast beef with mashed potatoes and gravy, onions, and corn bread. Supper was fried mush with molasses, bread and butter, and coffee and sugar. One thousand and forty inmates were fed that year for a total cost of $131,475.

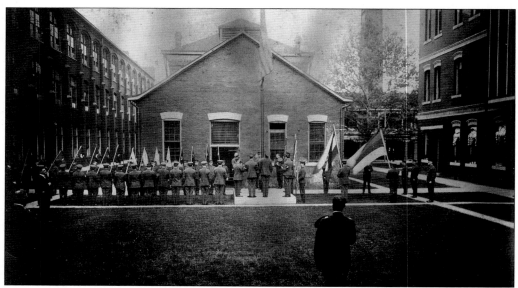

INTERIOR COURTYARD OF THE REFORMATORY. The small building in the center is the icehouse. A ceremony called "standing retreat" is taking place with the raising of the flag. It appears to be conducted by guards, with spectators, probably visitors, standing on the left. This courtyard was the scene of many activities.

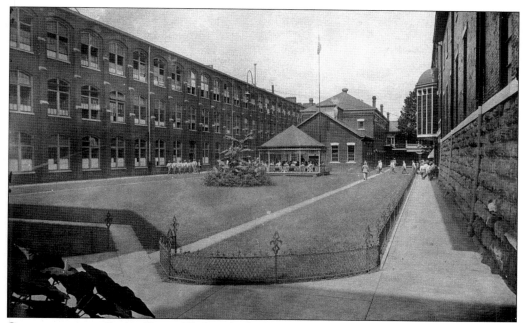

COURTYARD AT A LATER DATE. The gazebo had been built in front of the icehouse. On the left are the trade school, the dining room, and the bakery. The building on the right is the "A" Cell House. Much of this portion of the Reformatory was destroyed in a disastrous fire in 1918.

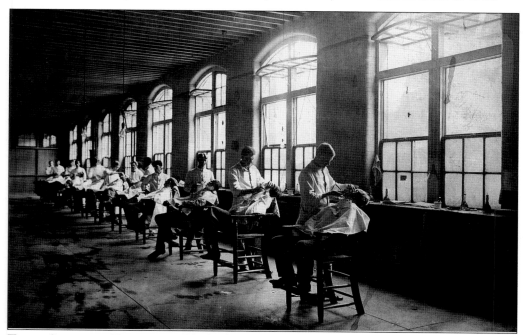

TRADE SCHOOL OF BARBERING. The barber school was begun in 1910. It had 12 chairs, running water, both hot and cold, and the latest tools used in the "tonsorial art." Fourteen hundred men were shaved each week and they gave each inmate a haircut once a month. Graduates of the trade school were called "first class Journeymen barbers."

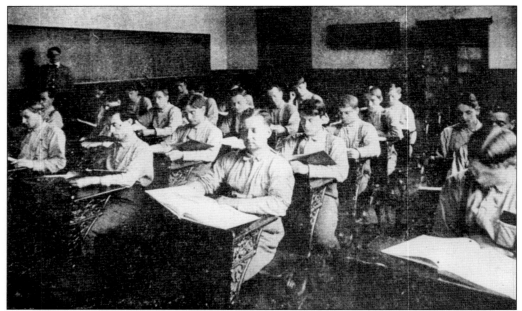

SCHOOL OF LETTERS. In 1906 the instructors were G.E. Mowrer, J.S. Potter, M.C. McKinley, and C.C. Engleman, and I.C. Reubelt was supply instructor and librarian. In 1906 there were 152 inmates in the school. Two had been found not "schoolable" and eleven "doubtful." Each man assigned to school was required to attend one session of two hours daily. Promotions could be made at any time.

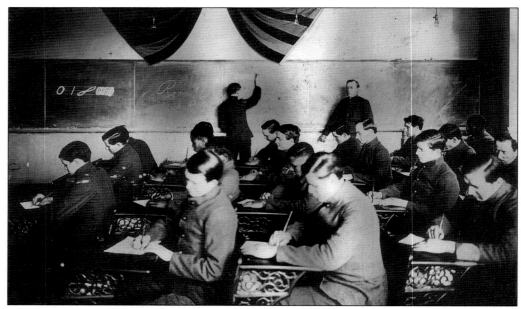

INMATES IN CLASS. The men were taught language, arithmetic, and U.S. History. There was a library and during the year 1905 circulation was 69,711. It was felt that "enforced idleness in the cell leads them to turn to the library for relief." The library had almost 10,000 volumes, most of which burned in the fire of 1918.

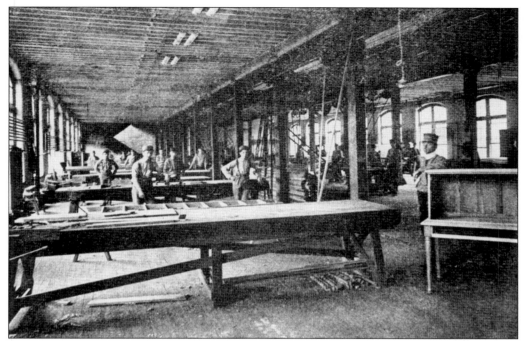

CARPENTER TRADE SCHOOL. The carpentry school was established in 1903. Inmates were given instruction in cabinetmaking, furniture repairing, wood turning, and carving. Architecture was also taught. In 1910, there were 28 men receiving instruction. The inmates made their own tools, which they took with them upon release. The Clarksville History Society has a chair made by prisoners. It features quality woodcarving and canework.

THE PRISON LAUNDRY. The laundry washed 9,000 items of laundry a week, and used 30 pounds of soap each day. Each inmate received his clothing washed and ironed. At one end of the laundry was the inmates' bathroom. The men were required to bathe once each week under the eye of an officer. An automatic spray gave a man a shower whether he wanted it or not.

BEING MEASURED BY THE BERTILLON METHOD. Bertillon was a Frenchman who was a proponent of the theory that various bodily measurements could be used in identifying criminals. He developed a filing system that put every person in one of three main categories based upon head size. He then subdivided them further according to the dimensions of the left middle finger, and so on down the line, using 11 different bodily measurements. These were to be taken of every criminal, enabling the police to identify him on subsequent occasions. The system was quite popular at the time and was superseded only when fingerprints proved a more efficient and practical system. Soon police departments around the world were using Bertillonage, as the system was known.

In 1892 he was appointed director of the newly formed Bureau of Identification of the Paris police. Eventually he was made a Chevalier in France's Legion of Honor. It has been said that he spent a year at the Indiana Reformatory.

116

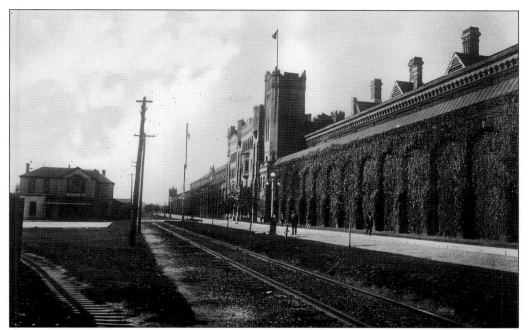

PRISON ENTRANCE, EARLY 1900S. The gate and tower had been built about 1887 and by this time was covered by ivy. The entrance and the tower were later painted white. The macadam road in front of the entrance had been built by inmates. The Dinky railroad track is just to the left of the road.

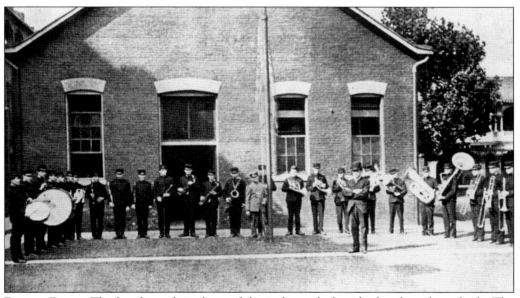

PRISON BAND. The band stands in front of the icehouse before the bandstand was built. The band was organized in 1898. In 1910 there were 36 members in the band. The director was a well-known local music teacher and musician, Henry H. Dreyer. The band members were each taught an instrument, as well as the fundamentals of music such as harmony, composition, and arranging.

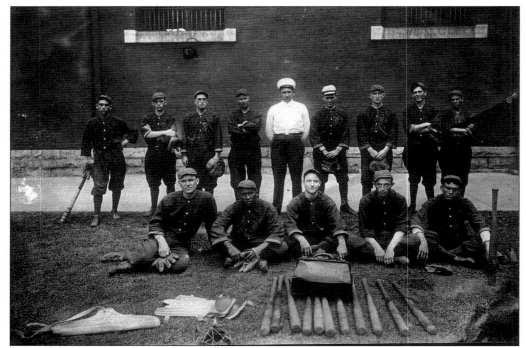

REFORMATORY BASEBALL TEAM. The inmates' ball team played other local teams at the exercise yard in the prison. They had their own uniforms and regular sports equipment. The team was racially integrated, which was not the standard in the early 1900s.

THE BASEBALL FIELD IN THE EXERCISE YARD. Prisoners are shown gathered to watch a baseball game in which the prison team played a visiting team. Third base in the foreground. A group of ladies are among the spectators on the porch at right. Sports were not mentioned in the annual booklet published by the administration. It may have been an outgrowth of the activities of the Brighter Day League, a leader in local prison reform.

DAVID C. PEYTON. A physician by training, he was superintendent of the Reformatory from June 1, 1903 to July 31, 1918. It was during his tenure that inmates were put to work saving the local town from the 1913 floodwaters. He was the superintendent when the fire of 1918 destroyed many of the prison's buildings.

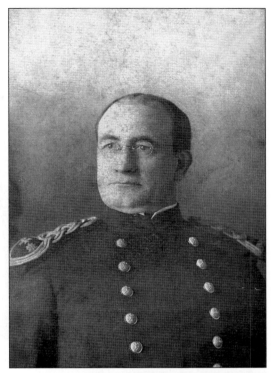

SNOWSTORM, JANUARY 1918. Guards and prisoners are shown shoveling snow from the courtyard after a big storm in January. Less than a month after this photo was taken, on February 6 of that year, much of the prison burned. The fire did $2 million worth of damage. It leveled three of the prison's buildings and damaged a fourth. Arson was suspected.

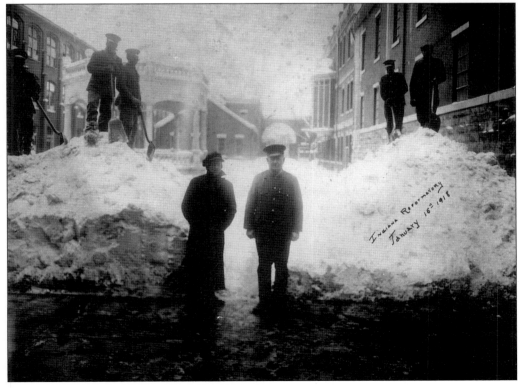

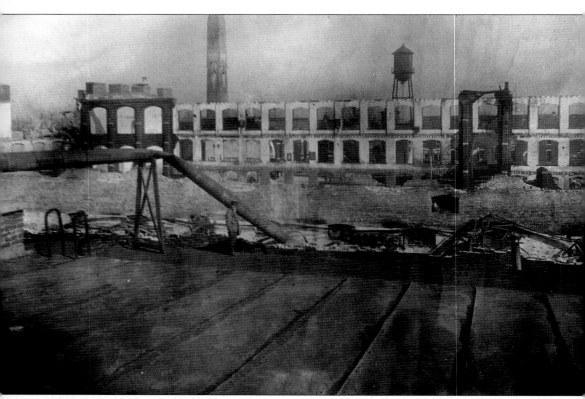

PRISON IN RUINS. Destroyed were the trade school buildings, the ice plant, storeroom and its contents, the chapel, the library with its entire collection, the administration building, general kitchen, bakery, and dining room. In addition the interior of Cell Houses "A" and "B" were destroyed. The tower of the power plant, seen behind the ruins, was later demolished.

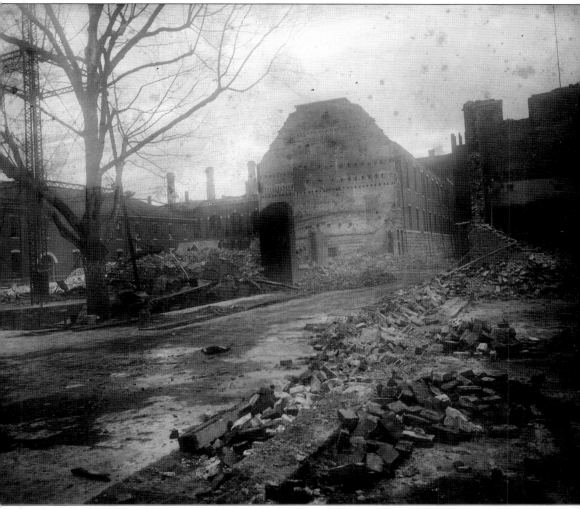

AFTER THE 1918 FIRE. Shown are the ruins of the Civil War-era chapel and hospital. This area also housed the death house, where condemned prisoners were hanged. The complex never really recovered from the disaster and the fire can be considered the beginning of the end for the institution. It is not known how many prisoners, if any, died in the fire.

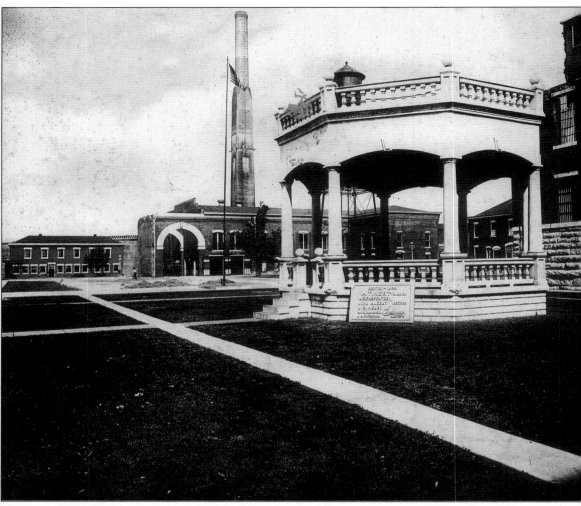

THE COURTYARD AFTER THE FIRE. In this photo the courtyard has been cleaned up. The gazebo that had been built about 1893, escaped the fire. A movement to remove the Reformatory to a more centralized location met with popular approval, since 75 percent of the inmates came from the northern half of the state. On April 19, 1921, Indiana Governor Warren T. McCray sold the buildings and site of the Reformatory to the Colgate Company for the sum of $351,101.

Colgate began the process of converting the old prison into a soap factory. Actual building operations commenced in 1923. For the first few months during the conversion about half the Reformatory inmates remained at the prison. When they were all finally removed to their new quarters, work was begun to tear down the wall that had surrounded the prison. The Warden's residence became the main offices. The first soap was pressed and wrapped in July of 1924.

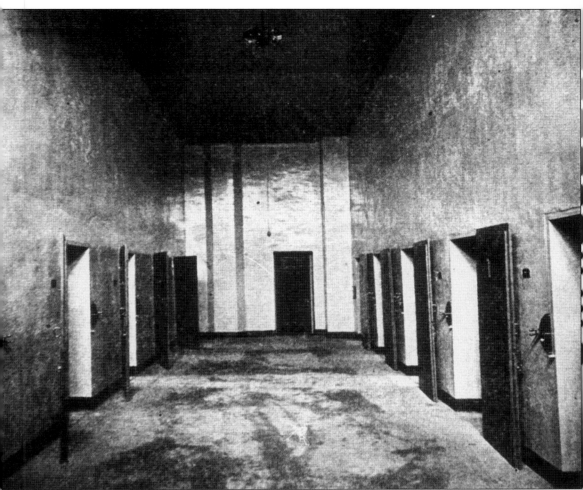

SOLITARY CELLS. The prison handbook states that "it was formerly the opinion of prison authorities that in order to secure the best results from solitary confinement, this should be in dark, close cells." With the advent of humane treatment, the dungeons that had previously been used were abandoned in favor of these solitary confinement cells, described as well-lighted and well-ventilated. If lower level punishment, such as fines did not achieve the desired effect, the inmate was placed in solitary confinement, and was compelled to stand during a certain number of hours each day. These solitary cells had "standing cages," which were a small area at the door, which could be enclosed by bars to form an area about two-and-a-half feet square. The average time for such treatment was from four to five days. In 1905, it was only necessary to use this method on 1 percent of the population of 1,050 inmates.

ALFRED DOWD. Dowd was on a baseball team that played with the inmates when Warden Peyton got to know him and offered him a job. He went to work at the prison as a tower guard in 1914 and stayed until it closed in 1923. Dowd, seen here wearing a navy blue summer uniform, worked his way up to become the assistant superintendent of the Reformatory and later the warden of Indiana Prison North at Michigan City. In an interview in 1978, Dowd spoke of life in the prison. "It was a very strict institution. We had a silent system. You couldn't talk or smoke at all. If you did, they'd add time to the end of your sentence." Taking one puff on a cigarette got prisoners 90 additional days.

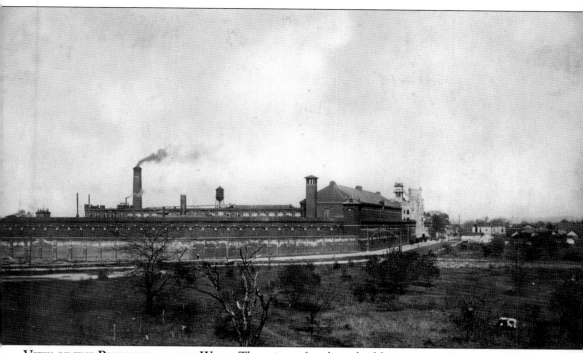

VIEW OF THE PRISON FROM THE WEST. The prison, four large buildings surrounding a yard, was a self-sufficient city. Prisoners made all their clothes and washed them, as well. A prison farm provided their food. The decorative wall, which was 4-feet thick and over 30-feet high, can be seen surrounding the complex. After Colgate bought the prison, most of the wall was torn down, and the bricks used for paving streets and erecting numerous houses in Clarksville. Some of the wall remains today on the east side of the facility. The official opening of the complex as the Colgate plant took place in 1924, with fireworks and a banquet for officials of Clarksville and the neighboring cities.

Index